INDELIBLE

A MEMOIR

SAMI MOSES

INDELIBLE
PRESS

ISBN: 9781088127797
Cover design by Michelle Butcher
Interior layout and design by Michelle Butcher

INDELIBLE PRESS

Published by Indelible Press
Printed and bound in United States of America
First Edition: 2023
www.indelible-press.com

For inquiries regarding bulk purchases, book club editions, special editions, or any other matters related to this book, please contact:
Indelible Press
contact@indeliblepress.com

Disclaimer: The views expressed in this book are solely those of the author and do not necessarily reflect the official policy or position of any other individual, organization, or entity. Any resemblance to actual persons, living or dead, or actual events is purely coincidental.

All names have been changed to protect the privacy of all.

Dedicated to Banksy, whose paw prints on my heart
remind me to be brave.

CONTENTS

AUTHOR'S NOTE

I was lying in bed next to my husband the morning after a long tattoo session on six different parts of my body. Wounds raw, blood and ink-filled pockets of covered fresh ink, lying next to the man who loves me deeply, and I love deeply in return. He turned to me and asked why I got my new tattoo; the other work was touchups to older tattoos. I tried to explain to him and quickly became frustrated with my inability to translate the emotions behind my decision. I wanted him to understand fully, and I could not get the words to transfer in a way that held the depth of my why. I wanted him to know all of me and couldn't share it well enough. After leaving the room frustrated, I sat at my computer and tried to write it down instead.

I started by making a chronological list of my many tattoos. My first was the butterfly, so naturally, I dove in there. Words came pouring out of me, and I realized I had a lot to say about my why behind each tattoo. Stories from my life, the good and the bad, fill my tattoos. I chose each of them with care; each is very special to me for different reasons. They stand for the growth and development I have gone through to become who I am today. They hold the power of many of my biggest life lessons, visual artwork for me to lean into when I need to recenter myself. The tattoos meant a lot to get, but arguably mean even more to me now as time continues moving forward.

Once I had written about several of my tattoos, it became clear to me that I was actually writing a book. I was not sure at the time whether this would be a book that I shared with the world or if it was for my husband and me to share only ... but I was all in from there.

This is that book. My memoir is told through my tattoos.

I organized my memoir in chronological order of when I got each of my twenty-eight tattoos. This means there are a lot of time and place jumps since most tattoos took many years for me to decide to get. There are many stories that led to me getting each tattoo, and I tried my best to include the stories that may help make clear the emotional experiences and life lessons each one holds. This means that each chapter (tattoo)

includes multiple stories, all related to my why for that tattoo.

My reason for publishing this memoir is that I believe that owning our own stories and being vulnerable from the inside out is one of the bravest and most freeing things one can do. I believe that being vulnerable can create magical change in the world. If my life stories can give one person, a handful of people, or tons of people the strength to share their truths and step into bravery, then it was all worth it. The hours of editing, the self-doubt and hesitation, and the tears shed overcoming my marketing fears ... all worth it.

With my descriptions of each tattoo, I have included illustrations of them. These are an illustrator's impressions based on brief descriptions I have given of each tattoo. They are not exact replicas of my tattoos, but they do include their key components. I chose to do this instead of exact replicas because the exact replica being out there for all to see is not the reason why I'm sharing my story. This is also a nod to each tattoo artist I hired, as each worked with me to create something personalized that was to be inked into my skin long-term. What these artists do is incredible, and what the illustrator did is a taste of that.

For me, my tattoos hold stories I cannot forget or remove, which is why I've chosen the title *Indelible* for this book. My tattoos are reminders of lessons learned and my growth and development through all different situations. They are hard to explain to a stranger who asks in a bar, "why do you have a wine glass tattoo?"

Let's not judge books by their cover; instead, let's lean in and get to know one another. Be brave.

You are about to read my why.

This is a story of a nobody. I am not famous or a household name ... I am a human, a wife, a friend, an ally, a privileged white female, a world explorer, a nurse, a program manager, a coach, a facilitator, a wine lover, a dog mother, a millennial, a feminist, and a mom. I am all these things and many more. I hope this book tells stories that people can see themselves in, including takeaways from which they may learn.

I am a flawed and constantly learning human being who wakes up each day and tries to do better than the last.

INDELIBLE

A MEMOIR

SAMI MOSES

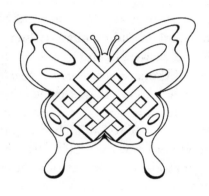

CHAPTER ONE
THE BUTTERFLY

Learning to play musical instruments was a part of my life growing up. I took piano, guitar, and alto saxophone lessons throughout my childhood. Though I was never particularly amazing at it, my favorite instrument was the guitar. I thought it was what the cool kids played. I took weekly guitar lessons between ages seven and ten, and my mom would always pick me up after class. There was a grassy patch outside the red brick building where I would sit patiently if she were running late. On one of those days when I had some time in that grass, my mom and brother walked up and sat in the grass with me instead of pulling up with the car for me to hop in.

She asked how my lesson was as she got comfortably seated. I went on and on about my lesson and got more comfortable as well. She then paused for a minute and said she needed to tell us something that was going to be hard to hear.

She looked at us seriously and told us she was very sick. She explained that her illness was not a type of sickness you get better from; instead, it was the kind of sickness she would die from at some point. She had metastatic breast cancer.

Doctors originally diagnosed her with breast cancer when she was thirty-one years old, and she had been in and out of remission since then. She was now in her early forties and had already started chemotherapy and radiation. Our mom was telling us now because she was losing her hair, and we were bound to notice. She pulled some out as she explained, and I thought, *wow—what a weird thing*, and even tugged on some of my hair to see if I was losing mine, too.

The thing I knew for sure when I was seven or so was that I was called and supposed to respond to Sami. I had a mom, a dad, a younger brother, two dogs, and a cat/mouser. We lived way up in the mountains, far from where we got food, played sports, or went swimming. Many of my friends lived closer to those things. We lived in a house with a blue roof, and it was a place that anyone who came to visit seemed to like. To me, at this age, it was a sanctuary full of forts and toys that I loved to play with. I had my own room, a wood loft bed, and a crazy amount of polar bear stuffed animals—and it was all mine! Life was good. My only complaint was that we were a twenty-minute drive from friends, a far distance for a child.

That day outside of my guitar lesson, my little world changed greatly.

We drove home with tears still falling, although many were falling for fear of the unknown more than from understanding the diagnosis. When we got home, several of my mom's friends were waiting, ready to help ease the pain of her hair loss and our new knowledge that life would not always be as it had been. They had scissors, razors, paint, hair dye, and more. We were going to PLAY!

First, we all decided what we must see on mom's head before there was no more hair to see. We dyed it multicolored. Then cut it short, then cut it into a Mohawk, before finally shaving her entire head. After it was all gone, we painted it before we looked into the mirror. Each of us created a masterpiece on her head and, of course, on our cheeks. We took pictures and laughed through each phase. It was a party.

We washed the paint away and tried on hats of all sizes, bandannas, and fabrics tied differently to see what we each liked the most. It made us feel like there was no loss, only change. Not a tear fell down my

mom's cheek, and all was going to be okay, even though each of us knew that feeling was temporary. We committed to each other that we would take on a life full of love and laughter and not waste a second of our time together.

~

When my mom was sick, one thing she (and therefore we) leaned on to help us process her dying was Tibetan Buddhism. This practice of Buddhism aligned with her core before she began studying it - always working to live in the present moment with the people around her.

Through the years, as she got sicker and sicker, we would discuss together how we should not fear death and should instead live for today. Living today to the best of our abilities, being good to all of which we encounter (trees, animals, people, the ground we walk on), choosing how we leave footprints, and moving accordingly. We discussed how she would always be with us, deeply rooted in our souls and memories.

To this day, when someone asks me if I am religious, I tell them, "If anything, I am Buddhist, but I call myself spiritual, not religious."

Through the spiritual practice of meditation and acceptance of her time on this earth not being as long as she had imagined, her Buddhist practice helped turn the facts into manageable feelings and helped her discuss what was happening with my brother and me. Through this acceptance, it made it possible for me to be with her through my childhood, my preteens, and on throughout each period of my life. Without the practice of Buddhism, there would be so many questions without answers, and it would be much harder for me to swallow that I would not get one more dinner with her. She would not be by my side when I got married or had my own children.

My mom gifted each of us and others she loved deeply with jewelry that had a Tibetan endless knot on it. She and I had necklaces and my brother and dad had bracelets. It was something we could wear when the going got tough to remember she was always with us. We discussed it as a symbol to help us understand that our love was lasting and would be there even after death. I knew we were all connected through the

endless knot and would always stay connected through life and death. To this day, I wear a Tibetan knot around my neck often and have it tattooed on my body always for those times when I forget to breathe (more on that later).

Years passed as my mom's cancer ravaged her body and slowly brought her fight for this life to an end when I was thirteen and she was forty-seven. I clung to different understandings of life and death through each phase of her death. Nature and love. Physical and spiritual. What it meant to combine my heart, head, and soul.

Through her passing, I discovered a different way of accessing her—through taking a moment to breathe—opening my eyes to the nature around me and slowing down. I could slow down enough to feel her presence in high-stress moments in my life as I moved forward without her physically there. But there was only one thing that pushed my thoughts straight to her without questions every time—and it was the butterfly.

Something about the carefree spirit of a butterfly encompasses what I imagine my mom as today. They are both beautiful and graceful. Nowhere and everywhere. Delicate and quick. Every time I see a butterfly flit past, I know she is smiling with me through that moment. There in my soul.

Reborn somewhere, somehow.

~

The butterfly symbolizes beauty, life, and, in some cultures, souls. My butterfly tattoo means those things and many more to me. I grew up surrounded by animals, mountains, wildflowers, love, and adventure. Each spring, I would lie in a field of wildflowers, hoping that a moose would cross my path, reflecting on how amazing this life can be—how massive moose are and how everything in nature has a place—including me.

Before she passed, my mom wrote and discussed many things that she wanted me to remember if I needed to access her knowledge or my wisdom. One of these things was to trust that my father's

intentions were sound and that he was always on my team, even when it was not obvious to me. This was something that I had a tough time comprehending, especially in my teens.

My father was a well-known physician who always seemed short on time. He was a hard worker, and that was clear. But the way he showed his love was often less clear to me. He was tough on me and had high expectations. I felt like he did not understand me and, on many occasions, never would. Although we weren't on the same page, I still respected his opinion and would try to work with him. Yet as a teenager, I did not always succeed in this.

One of the many things I brought to him during those more challenging years was that I wanted to get my first tattoo. I wanted it before I turned eighteen, and I wanted it badly. I told my father I wanted to get a butterfly tattoo to represent my mom, and that I wanted the eternity knot somehow also intertwined with the butterfly. I explained my "why" and waited to hear his judgment.

He said plainly, "I understand your reasoning and think it is a nice sentiment that can wait until you are eighteen."

I cried and tried harder to push for a yes, as I needed him to sign the paperwork because I was underage. I fought until he reluctantly conceded.

He said, "I understand and will support any decision you make as it is your body, but I really wish you would wait. Wait to see if it transforms in any way, or maybe you decide you don't want a tattoo at all. And if you still want it the way you've described it or another way, once you are eighteen, I will be excited for you."

I stomped up to my room with the signature I needed for his approval in hand but with a heavy heart, knowing I had won, but not in the way I wanted.

I spent hours pondering whether I would take my next step with him in full support or if I would claim my body and do what I wanted now. I went through the many mementos that my mom had left me. I had kept and read journal entries from my mom to find answers in those. Based on that time of reflection, I finally decided that I wanted to have a better relationship with my dad—one full of mutual respect,

honesty, and love. And I knew I had an opportunity to change our path right then and there. I went back downstairs with the signed paper in hand and returned it to him, saying only, "I will wait."

Weeks went by, and we did not talk again about my request. Nothing changed, really, and I assumed we wouldn't discuss it again until I was eighteen.

One day, I returned home from school to find a little black box sitting on the kitchen counter with a small piece of paper with my name on it. In it, there was a beautiful butterfly necklace. My father had taken my idea and created a necklace that resembled what I had described. It was beautiful, and I could not believe it—he had heard me! Understood me! His words with the gift were simple: "Thank you for waiting, and I hope this brings you the same sentiment in the meantime."

From then on, our relationship blossomed. We found things we both enjoyed doing, and we started choosing to spend time together. We even started taking a photography class together.

And when I finally turned eighteen, I didn't rush to get the tattoo. Giving myself a few months to have the complete image in my mind of how I wanted my first tattoo to look. It ended up being very close to what I had described to my father that day.

What I learned through that waiting period was confirmation that he did support me, just like my mom had told me. He did want me to be happy. He did love me. I did love him in return. I did want a relationship with him that was stronger, better, and smoother. I did want a butterfly tattoo with an eternity knot inside it to symbolize my mom. I did have the ability to wait.

She had done it again—helped me make my decision—even after she was gone.

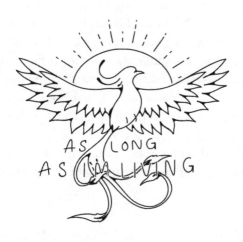

CHAPTER TWO
THE PHOENIX

The death of my mother left me reeling. There were moments where I felt a pain that I could not describe with words, moments where I felt sadness like my heart was no longer in my chest, and even moments where I felt relief because the weight of her slowly dying was finally complete. All these feelings required a lot of processing and a lot of putting on a straight face to get through the day.

Overnight, everything changed. I now had to figure out how to wake myself up for school, get my brother ready and fed, make sure we had groceries and plans for lunch, and figure out how to get myself and my brother to and from our after-school activities and then home. These things individually were not rocket science, but they sure as hell felt like it sometimes. I was thirteen years old and felt thirty as I opened my eyes the next day.

Over time, I practiced my methods of communication, both new and old, with all the adults in my life, including asking for help. Bus drivers, parents, and neighbors helped us get to and from things. They helped make sure we had lunch money and casseroles in the fridge. Those closest to us physically and emotionally made sure we were safe,

calling to check in, always answering when we called, and reminding us we would be okay even when we did not feel like we would.

Our dad was navigating an even bigger nightmare in addition to a doctor's schedule. He was suddenly in charge of everything our mom took care of, no questions asked. He was grieving and parenting in a way he had never had to do before. Where we lived made it hard for us to get home and to and from our sports and activities by ourselves. Eventually, we decided a nanny was required.

The phoenix in this story was a mix of all of us picking ourselves up from the ashes of grief and learning to be a family in our new form.

~

When I was eight years old, and my brother, Michael, was five, doctors diagnosed him with type 1 diabetes. Each day was a challenge as we learned how and when his little body needed things. It came with rapid mood swings, lots of orange juice offerings, and pricking our fingers to help support him in testing his blood sugar.

One day, about a year after our mom passed, my two best friends were over, and we were obsessing over our new ear piercings. We desperately wanted to go to the local jewelry store before it closed to buy new earrings. We convinced the nanny to drive us but had to convince my brother to come along. This was not easy as he had zero interest in getting into a car with talkative older girls to buy earrings. Let's just say we don't blame him in hindsight.

He kicked, screamed, and begged to stay home. We debated, checked his blood sugar, and decided he would be okay for the forty-five minutes we would be away. We convinced the nanny of the same, and the four girls got in the car to set out on our journey.

Before leaving, I made Michael promise to answer the phone no matter what he was doing.

Ten minutes later, we were in the car, driving across a mountain pass between two canyons to get to the freeway and head to the mall. Suddenly, I had a funny feeling that I should check on my eleven-year-old brother, so I called him. I first tried his cell. My call went straight

to voicemail, which immediately annoyed me. Michael promised he would answer!

I then called the house phone, but it didn't even ring, it just went straight to the busy tone. I started to freak out and told the nanny to turn around. I kept trying to call as we headed back to the house, all talking about how annoying Michael was for not doing what he said he was going to do ... boys! Our earring mission had officially failed as there wasn't time to get there after checking on him, as the store was close to closing.

We got home as the sun was going down. We had been gone for less than twenty minutes at this point. As we pulled up to the house, we could see that all the lights in the house were on (a good sign in our minds as they were off when we left). I jumped out of the car, ready to find him and yell at him for scaring me. We got inside and immediately noticed things weren't quite right; all the cupboards were open, the home phone was off the hook, the TVs and radios were all on, and Michael was nowhere to be found. The four of us started searching for him everywhere, and by now, we were very worried.

I stopped in the kitchen area after checking everywhere I could think of, covering my face with my hands, taking a deep breath in to slow my thinking, and racking my brain ... where could he be? As I pulled my hands down my face, I saw his feet from behind the fireplace in the living room on the lower level of the house. It was a wood-burning fireplace about a foot off the outside wall.

I ran down the set of five stairs to where he lay. There was blood coming from his nose, mouth, and ears. He was unresponsive but breathing. It looked as though he had hit his head and was unconscious.

I started to yell at the others.

"Sarah, call the neighbor," (who was a life flight nurse) I yelled. "Emily, call 911. Brittany, find the orange emergency glucagon. Hurry!"

I pulled his body out from behind the fireplace and tried to wake him, to no avail. Within seconds, our neighbor was there and started caring for him and sent me to help find the glucagon. She used other methods to get glucose into his body; we all knew a low blood sugar crash likely caused this.

I took over the 911 call and was on the phone with a woman, trying to keep everyone calm. I'll never forget this woman's voice.

She repeatedly asked, "How old is the child?"

I kept answering, "He is eleven."

After the sixth or seventh time, all I could think was, *He is not going to turn twelve while we are on the phone! Just get here!*

As the paramedics arrived, Michael started to seize because the glucose that we were able to give him had kicked in, and he was waking up (this is a good sign in this kind of medical emergency). The paramedics managed his seizure, and the rest of us watched in horror. There was vomiting, blood spitting, and body movements that I can only describe as terrifying. Let's just say we never cared about earrings again.

Then, our father's friend Bryan showed up. We had trouble reaching my dad as he was swimming and called his friend during our search as they were often together, or Bryan knew where to look for him. Bryan, also a doctor, took over as the adult in the house until my dad showed up a few minutes later. My father was furious.

"This could have and should have been avoided," he screamed at me. "How could you leave your brother alone? How could you put his life in danger, especially after just losing your mother?"

Dad was right and just as scared as me. His fear was showing up as anger, but I knew deep down it was love. He was in a panic, almost losing another part of himself to death. I knew because I felt the same. I knew because I had already promised myself that I would never again put my desires or needs above my brother. Never ever again.

As my dad yelled, my brother sat eating cereal as he needed food in his system to raise his blood sugar. Suddenly, Michael threw up in the toaster! My dad stopped yelling and went to help him, and I thought ... *yup, the toaster is now dead, but my brother isn't. Thank fucking God.*

At the time, Michael was a phoenix, and I realized I would be too after experiencing this near-tragic event.

≈

Before my mother's death, she sat down with my brother and me and told us she wanted our father to be happy after she was gone, no matter what that meant. She shared with us that she wanted him to find love again and that she hoped we would be okay when he was ready. We cried and said she would always be our mother and that we would always love and remember her. We said we would support him when the time came and that we understood that his happiness mattered to all of us above anything else.

Michael and I were close, but we were siblings. There were moments when we were as close as two people could be and others where we were each other's nemesis. After this chat, we couldn't be closer. Without words and with silent tears, Michael and I went to his room, sat in silence, and cried—holding each other and knowing exactly how we were feeling. We sat like that for a long time.

We sat like that until we both dared to leave the room without tears. We knew our love for each other, and our family was powerful, but we also knew we needed to be brave for our mom and dad during this time. Our family was great at loving each other out loud, meaning we supported each other and celebrated life loudly! We announced ourselves when we walked into a room and said, "I love you," every time we left the house, went to bed, or even just because. Michael and I wanted to leave his room, ready to love out loud again.

We knew there was not much time left with our mom, but we didn't know whether we had weeks or months left. Within months, she passed, and Michael and I held one another again until we could feel that strength again to keep loving out loud.

A few years later, our dad sat us down and told us he was considering dating again. We grabbed each other's hands under the countertop so he could not see our fear.

We said, "We support you and want you to be happy."

He looked at us with surprise and gratitude and said, "Okay," nervously.

We said we loved him and took to the stairs. We went into Michael's room again with silent tears and held each other until the tears stopped and became smiles. We had just seen the most extraordinary form of

love in action and unknowingly been a part of it. Our mother had told our father that she wanted him to be happy and re-partner when he was ready after her death. She permitted him, through us, to allow all of us to love out loud even after she was gone.

Just before my senior year of high school, our dad remarried a woman with two kids of her own, and we all moved in together as a "blended family." There had been a lot of ups and downs throughout that (almost) year together before I went on to college. No matter how hard I tried to grow the love between my stepmother and I, I could not get her to see or hear me how I was trying so badly to be seen and heard. Life wasn't fair, which I learned repeatedly. We had two stepsiblings whom our stepmother treated differently. Some of this made sense, as they were *her* kids, but some of it did not. It felt like she gave them more forgiveness, more privilege, and less accountability.

She and I butted heads many times, and I could not wait to move on to college. My final day of living at home was another rebirth experience. I had gotten home and wanted to check in with my father about whether, on the following day (my mom's death anniversary), we were going to my mom's trees, which had been dedicated to her before her death by our family. They represented a place that we could visit since we had her body cremated. They were in the garden that she loved and where we had her celebration of life. Historically, we would walk around the garden and think about my mom, mostly in silence, but together. I knew this would not be something my stepmom liked, so I looked around the house briefly to ensure she wasn't close by before approaching my dad in the kitchen.

I walked up to him and said, "Hey, Dad, are we doing anything tomorrow?"

Before he could respond, my stepmom came around the corner and said to me, "Sami, your mother is dead. Get over it. He's spending the day with me." She put her hand on his shoulder and glared.

I was at a loss for words and didn't trust myself to stay in the room even long enough to hear whether my dad would respond, so I ran. I left the house sobbing because I knew deep in my soul that her love and mine would not meet and flourish as I hoped. I couldn't understand

what I did that was so wrong. I couldn't understand why loving my mother even after death had to feel like a sin.

Without hesitation, I called my aunt, who got me a job at an all-girls camp in Virginia, close to where I would attend school in the fall. I thanked her, packed my bags, and left Utah. Knowing there was damage that would take years to mend between my father and me. Worried that I was leaving my brother behind and hoping he would be okay. I hoped he understood I had to go for myself and would always be there for him.

I made it to Virginia, in the country underneath Jump Mountain, knowing only my cousin who worked there. I sat on the side of the hill and looked up at the big blue sky, sitting in my sweat and tears after a full day of teaching soccer, and I knew moving this way was one of those moments that would change my path. One that makes or breaks you, and I, sitting on that mountain, chose the former.

I wanted to make something of myself, be someone who my mom was proud of. Be the strong and caring woman that she showed me and set me up to be. I decided then that I would be the woman I was meant to be, and I would not allow the pain of moving early, leaving my family, and shifting my goals with my stepmom to crush me. I would allow myself to come from the ashes and still remember to love others out loud ... even when no one returned it.

∽

The day my father said, "Maybe college isn't for you," is the day I realized I was the author of my story. I certainly did not have everything figured out. I had been failing my first-semester classes and was at risk of being pulled out of college to get a minimum-wage job and who knows what else. I was sitting on my dorm room steps when he said it over the phone to me as I stared out at the campus, feeling very small.

I took a deep breath and decided I would turn my grades around at that moment. I told him I would get it together and asked if he would give me a chance to fix things. I hung up the phone, stood up, and knew from that moment on that staying in school mattered to me and

I would do anything to succeed, no matter what it took.

I started working with a tutor on campus to help me memorize all the information I struggled to keep in my brain (art history, philosophy, etc.). I hated all my courses, but they were all general education (required) courses ... so I had to get over it and work hard. I spent hours and hours studying, as I had to ace my next exams ... all A's in all five courses. It was my only chance to pull my grades from F's to C's and pass my semester.

I set study goals. I asked friends to study with me. I did what it took to pass those horrible classes and prove to myself and my family that I wanted to stay in school and make something more for myself. Do not ask me anything about these topics (no offense to those who love them), but they weren't for me then and aren't for me now. As soon as I passed my classes, the information left my brain.

Getting my phoenix, my second tattoo, represented those times when I felt reborn. When you feel like nothing will be the same as before again. When you feel in control after being extraordinarily out of control.

I had the artist tie in the words "as long as I'm living" to the phoenix's tail. These words were part of what my family sang together every night before bed.

> "I love you forever,
> I like you for always,
> As long as I'm living,
> my baby you'll be."

These words are from a great children's book, *Love You Forever*, by Robert Munsch (Firefly Books, 1986). They fit perfectly with my phoenix as it represents how strong we are at our core and how much love we have to give within us. They are a reminder to continue to love even through these life-shattering moments, the biggest of lessons, and the times when all you can do is take one more step forward ... over and over again.

∽

The number of times we feel rebirth throughout life depends on the individual experience. My story had several of these moments at a young age—the moments when you know nothing will be the same from now on, nothing you knew before will feel like it did before, nothing.

Before getting my phoenix tattoo, my first rebirth was after the death of my mother. My second was when my brother had a low blood sugar episode that almost killed him (and what was left of me after my mom's death). The third was when I said enough and moved away earlier than planned before starting college. The fourth was when I finally realized I was the author of my story. My phoenix tattoo represents these and all the other experiences I have had that are life-shattering, both bad and good. It is on my ribcage and is part of my breath as I breathe through all life has in store for me.

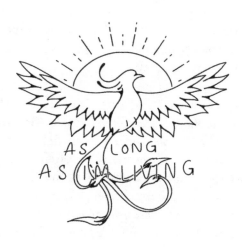

CHAPTER THREE
THE PHOENIX RISING

Life has brought more phoenix moments in my life since getting my tattoo, and my phoenix continues to be a reminder for me that rebirth is something to grow from, learn into, and become an even stronger, better person because of whatever the circumstance. Even when these times come with getting knocked down and having to get back up. Or when you choose to continue trying to be good even when you are carrying scars and empty holes from losing someone. Or even through the lessons that hurt so much—choosing to be good, being better than you were before because of it, using your experience as knowledge, and working to impact the world positively. I believe that is worth fighting for every day.

～

Growing up, I went camping a lot with my family. We did all different versions of being outdoors; hiking and camping, river trip camping, glamping, and more. It was an activity with loved ones that always centered me back into the moment. There are survival skills you learn,

like how to start a fire, pack what you need and nothing more, pick up everything you brought with you so that you aren't hurting the planet, and what to do if you are in an area with bears and other creatures, all teaching you how to be prepared.

I loved it.

I co-planned several camping trips with friends in the Shenandoah National Park in college. The Shenandoah Mountain range was beautiful, protected, and lush. There were small black bears and poison ivy, but little to worry about otherwise. We often returned to a favorite camping spot we found off the beaten path that didn't cost money. It had a fantastic view with a rocky cliff ledge nearby that we could climb on and sit on. We felt like we were on top of the world. The Appalachian Trail ran at the base of the cliff, and we heard other people trekking as they passed by at a distance.

One trip was life-altering for me. One of my best friends at the time, Chris, came with us for the first time. On the trip, there were six of us, two girls and four boys, all of us were close friends. Chris and I had a slightly complex history. We crossed the line into friends with benefits a few times but never made it more official. Things were not simple, and the timing was never right for us. We were best friends, and our friendship took priority over whatever other feelings we may have had for each other.

Going into the camping trip, we were strictly friends and on the same page about it. It was his first time going camping, and we planned to share a room in a huge tent that slept eight. This tent had three rooms, two doubles on the ends of the tent, and one large central space that technically slept four. Since he and I were comfortable with one another, it made sense that we would share one of the doubles, the other girl and one of the guys were a couple so they would share the other, and the two other guys would take the middle, so everyone had plenty of room.

We had a fire, ate and drank, and were merry. We danced, looked at the stars, and lived in the moment, away from school and work stress and deep in nature. It was an epic party; it felt like we were each releasing some shit that had happened recently and letting it go. When

it came time for bed, we all headed to our assigned sleeping section and lay down.

A few minutes later, Chris came closer and started spooning me. I hesitated with what to do—loving him as a best friend and having the history we had ... this made things complicated.

So, I decided to allow the spooning.

Suddenly, he started touching himself, and it became clear that he intended to do more with me. We were both intoxicated, but he was, especially. I tried talking with him and joking about it quietly (we were in a tent, after all).

I whispered so only he could hear, "no, Chris, we can't," which was a loaded sentence.

We can't start being sexual with one another again. We had discussed this and decided together before. We cannot have sex in a tent with four others. We can't do anything like this ... not now. Not intoxicated. He continued to try, and I continued to try and whisper reason to him and push him back.

He didn't stop trying; I couldn't get through to him without making a scene. He pinned me between my sleeping bag and him and pulled my pajamas down just past my butt. He pushed himself into me; I held my breath and waited, knowing it wouldn't take long. It was not that kind of sex. He finished and passed out. I cried silently, trying not to wake the others, and lay awake for much of the night.

Early the following day, before anyone else was up, I went out to the rocky cliff side, climbed up to the top of the highest rock, and sat watching the sunrise, thinking about life and what had happened. Re-centering myself, I worked on not blaming myself for what happened and tried to figure out what I would say to him when we talked next. I sat there for hours, holding the phoenix on my ribcage as I held myself, sitting somewhere that was hard for anyone else to get to and safe, exactly where I wanted to be.

When I climbed down, Chris was there. He said, "Man, Sami. You sure know how to live." I stared back at him and said, "Yup." Then, I walked away.

As the day went on, it became clear that he didn't remember what

had happened the night before beyond a specific time. I told him at one point that we had sex, and he said, "Really? Oh, that must be why I feel so good today." I dropped the subject in a bit of shock.

He raped me, and he didn't remember?

I closed my eyes and turned inward to my phoenix and never talked about this event to anyone outside of therapy simply to move forward.

~

When I lived in Austin, TX, one of my first jobs was as a server. The job was not my favorite, but I enjoyed the people I worked with and made the most out of my time there. My normal shift would end late, but the parking lot felt safe enough as it was in a strip mall and well lit. I would still try to get to my car as quickly as possible or walk out with another person at the same time.

One night, driving home late, I had the eerie feeling I was being followed. I looked in the rearview mirror and turned where I wouldn't normally turn to see if I was making it up. The car behind me also turned. I made another turn, and so did they. I sped up and tried to lose them. They stayed with me. I went a super bizarre way back to my apartment complex, continuously trying to shake the tail. I thought that I might be able to get inside the gated apartment complex I lived in without them being able to follow me inside the gate. They were still in sight, but I got ahead of them. I opened the gate and drove in quickly, watching the gate close behind me.

Just to be safe, I parked far from my apartment and sat in the car for a while, not trusting that they were gone. After twenty minutes or so, I moved my car closer and got out. I paused when I quietly closed the door, listening for other movements in the night. Not hearing anything, I started walking toward my building.

My building had a set of stairs with both a front and a back staircase. As I climbed the front stairs, I felt someone else was watching me. I turned and saw a man coming towards me, not running but moving briskly. I started moving faster, and he started running up the stairs. Panicking, I ran back down the back stairs and pounded on a neighbor's

door (hoping that he would be awake). He answered, and I pushed my way in, closing and locking the door.

I told him what was happening, and he told me to stay for a while and that he would walk me home later, also offering to walk my dog with me once we felt sure there wasn't anyone outside anymore. We did just that, and everything was okay.

I was lucky that my friend answered the door and that the man who followed me had not waited somewhere for me to leave my friend's apartment. The following day, I sat and pondered what I would have done if he had. I came up blank. I could not stop thinking that I was the only person in Texas with no gun.

Bringing my fists to a gunfight did not make me feel safe, so I went to a shooting range. I told the guy behind the desk that I was considering buying a handgun, and he talked me through my options and told me I could try them out in the range to see which one I liked best. I went back and shot several of the choices at the target. I felt powerful, scared, and awkward. Glancing around, I realized I did not fit in at a gun range; it wasn't a place I enjoyed the way that others around me seemed to.

At that moment, I thought hard about the gun experiences I'd had—the two people I saw shot to death in front of me, being robbed at gunpoint, all the horrible things I heard on the news, my time in the emergency department where I worked and cared for several gunshot victims (some of these stories will be told later). Thinking about the statistics that I knew were true, it was unlikely that I would be able to protect myself from harm, even with a gun.

I left the shooting range sans gun, ultimately deciding that getting one to protect me from the unknown wasn't a good enough reason to own one. I didn't live in the woods or in a place where it made sense for me to have a weapon like that in my home. I leaned into trusting that my awareness and quick thinking were better weapons.

Once again, I returned to my phoenix and reminded myself that I was a do-no-harm person and that I was strong, maintaining my values and staying safe.

Fear is part of life, and I would argue it is necessary to maintain

awareness at times like these. Fear is a tool if you listen; trusting your gut and leaning into what you know to be true and safe is always better in these types of scenarios.

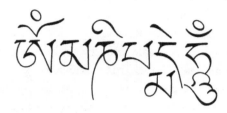

CHAPTER FOUR
OM MANI PADME HUM

A couple of years after my mom's passing, my best friend was spending the day at our house, and we decided to make some baked goods. We got out all the ingredients we needed, including powdered sugar. We opened the powdered sugar, and it *poofed* out a bit, making a mess. We giggled and decided to play some first instead of cleaning it up. It was an epic powdered sugar fight full of laughter until we had none left to throw.

Emily and I were fifteen, and we loved to laugh and be spontaneous together. We always pushed boundaries with our families to have the most fun possible. One thing that made our bond tighter was that one of her parents passed away when she was young, too, so we were able to hold each other's pain differently than most kids our age.

This food fight was not a well-thought-out plan, which we realized quickly after. We had twenty minutes until my dad would be home, and we knew he would not find this as funny as we did, so, we rushed to clean.

Grabbing the mop and all the cleaning supplies we could find, we started cleaning the counters, only to realize that once you add water

to sugar, the result was very sticky. We knew we were in trouble with a capital T. We became more anxious when we realized that powdered sugar was now in every single cupboard and crevice, on every single plate and cup in the cabinets. It was everywhere!

We devised a plan after our second attempt to mop (it was still sticky, if not stickier, after the second go of it). We would ensure that nothing was still white in look and try to keep my dad out of the kitchen when he arrived home. This made sense to some degree, but we continued down the path of water being the solution, which was and is ill-advised. The CD player was sticky, and so was the toaster. The handle to the fridge was sticky. We were sticky.

Needless to say, he found out quickly that something had happened, and we were at fault. He was angry; our job was to mop until there was no stick left ... and then do it again. We had to clean for hours, and then my dad and I would discuss my punishment in his office. I knew this would be a big one, and Emily knew, too. After cleaning, her mom picked her up, and I walked slowly, breathing through preemptive tears, to my dad's office.

He first asked me, "What were you thinking?"

I replied, "We weren't. We were having fun."

He did not want to hear this response, though it was the truth.

He said, "You aren't allowed to have any more sleepovers in the near future."

This was like being sentenced to death for me at that age. I cried and yelled and stomped my feet in response.

"That isn't fair!" I cried.

He said, "Life isn't fair, Sami. You will also be going to Tibet."

This one threw me for a loop as I wanted to go to Tibet because my mom studied Tibetan Buddhism. It did not feel like a punishment, and the idea baffled me. I fought a little less hard and said, "Fine." He set it up, and off I went as soon as summer break arrived.

In hindsight, this is one example of many experiences that highlight my privilege. Most parents would not send their children to a foreign

country to learn a lesson after pushing too many of their buttons. I acknowledge this and feel very grateful to have been able to learn many of my lessons through privileged experiences like this one. I even have a tattoo on my ribcage that represents my time there and the lessons I came home with.

~

I was to meet our family friend Susan and her team in Hong Kong, and then we would travel together to Tibet. Susan owned a nonprofit that focused on reducing maternal morbidity in developing nations, addressing nutrition, overall health, and wellness of pregnant women, and traveled to small towns and communities in rural places worldwide. I would be with her team and help wherever possible, no questions asked. I would work at an orphanage some days, and shadow/help meet with pregnant women on other days. I was beyond excited.

On the first day, they gave me a shared hotel room with Susan's niece, who was also traveling with us. She and I explored our room together, taking in the strange ceiling, bathroom, etc. After a few minutes of the first pass to check out the room, we went back into the bathroom to see how the shower set up worked. Although it was a spout coming out of the wall like most showers, it was right beside the toilet, without a separation between the two. We weren't sure how you would turn the shower on and have the water drain properly, so we tried it out together.

One of us leaned over the toilet to turn the handle to the "on" position. The shower started spurting water; the next thing we knew, the toilet had tipped over. It spewed dirty water all over the bathroom and us. It was disgusting. We turned the shower off and called for help. The person who had previously checked us in came into the room and lifted the toilet back up, covering the hole in which everything else was coming out. He then tapped the seat and said, "don't sit too hard." In shock, we just nodded. That was the first moment I felt in my bones, *we were not in Kansas anymore.*

Later on, we were sitting and talking in the room when we heard

some scratching noises above us. It was one of those ceilings with square pieces you can push up and move. We both looked up in response and suddenly, a tile fell onto the bed—followed by several rats! They bounced off the bed and onto the floor. We screeched, jumped onto our beds, and yelled for help again. The same guy came running in, assessed the situation, and returned with a broom-like tool. He swept around the room and removed the rats. He placed the ceiling tile back into position and said, "okay, all good." We again just stared and nodded back in response.

In hindsight, one of the beautiful gifts at that moment was that the guy who worked at the hotel spoke a little English and had a sense of humor. Later, I realized how rare those two things were in Tibet.

∼

During my time in Tibet, I had gotten used to seeing the extremely poor Tibetans on the streets begging for help, starving to death, needing medical care, and more. Not drug addicts or mental illness, just people trying to survive. As days passed, I walked the same street with the same people begging for money each day. I would leisurely go shopping at the flea market on my way to work or go to the restaurant down the street because I was tired of the food offered at work or the hotel (mostly yak in different forms ... it is very gamey. The restaurant down the street had tomato soup that I ate as often as I could to avoid another yak burger).

Others traveling with me advised me not to give too much to beggars, as my concept of money differed from theirs. I had also noticed an average of three Chinese military men per Tibetan (this was my visual math and nothing more official). The importance of this will be clear as I share this story.

One day, I decided I couldn't take it anymore, and I needed to share my wealth with the people who needed help. I walked down the street (with my bodyguard/translator/friend) and gave small amounts of money to each person begging. There were tears of gratitude and genuine thank-you's. I was on top of the world as I gave what I could to

those in need. That is until I turned back to look at what I had done.

There I saw a Chinese military man yelling at someone I had given money to. I asked my translator what was going on, and he responded that the military man was asking the man to "pay his taxes."

"Pay his taxes?" I said, "He doesn't have money for that and doesn't own anything in China."

It made no sense, and it immediately enraged me. I started walking towards the two men, one yelling and wielding his weapon and the other on his knees, crying and begging to be forgiven.

My translator grabbed my arm and said, "No. You can't go over there."

I said, "I have to ... I will pay the military guy what he is trying to take. It isn't fair."

I turned back around to keep walking and saw the military man aim his gun at the man's head. I screamed "Nooooo" and heard a burst come from the gun, then saw him take the money that the man had been holding in his hands and pocket it. Blood came from the man's head as he slumped lower to the ground, and his eyes became lifeless.

All in one breath, with the word "no" barely escaping my lips, I was over the translator's shoulder, and he was running. We got to an alley, and he set me down. He grabbed my shoulders and said, "This isn't your fight."

I could barely see or hear him and remember thinking ... *If this isn't my fight, then what is? If wrong cannot be made right in this situation, what hope do we have to make it in this world? If good cannot defeat evil for a starving man begging for his life, then when can it?*

I don't remember much after that moment that day, but I went to bed still in tears, feeling like not only had I not helped that man, but I had quickened his death.

The following morning, I went to the temple, thought of the man, and asked for forgiveness. Not having done anything like this before, I attempted atonement the best I could. I was trying to forgive myself for not being able to stop it, not being strong enough, and not realizing that my version of help is not always what someone needs most. In hindsight, that man would have been better off if I had brought him

food that day, and maybe he would have survived a bit longer.

～

The Tibetan people could not have been kinder to me throughout the trip. Many of them had suffered so much loss and pain, but they continued to hold their heads high and have hope. The Buddhist religion guides some of the cultural spirit, including significant concepts like choosing peace instead of fighting back. They were genuine, good people who believe in karma and helping all instead of one. An example exemplified this during a festival that we went to—there was going to be a horse race. It wasn't just any horse race, but a skills horse race. Each rider would canter down the line and do different tasks during their ride, and the rider would receive a score. Everyone was extremely excited.

The beginning of the race was confusing to me. Everyone assembled in one area, outside on flat land, in a clump. There were not any apparent signs of a course or plan. I stood in the crowd, shorter than many, and tried to understand what would happen and when.

All at once, I heard people yelling and saw them jumping out of the way. A man with a stick came down the middle of the crowd, screaming and smacking people as he went. Everyone he hit jumped to the side and stayed ... as he got to me, people were already bumping into one another, trying to get out of the way before being smacked. I got bumped around and felt a small amount of fear, but I got to one of the sides without being hit.

Once on the side, I looked around to see why we had parted the way we had. Just as I looked to the left, a man on a horse appeared, moving as fast as possible. He had a bow and arrow, an ax, and other things attached to him as he rode. He was whipping the horse to get it to move even faster and was going right down the middle of the group of people. People were close enough to touch the horse as he passed ... less than a foot from the race line. I immediately held my breath and watched like you would a car crash.

He started shooting his arrows at targets I had not noticed before.

They were taller than the crowd by a bit, but not too tall for someone to pull the arrow out right after it hit the target, as more racers were coming soon. The first race happened in the blink of an eye, and the crowd closed behind the rider almost as if you blew two papers apart, but they returned to touching. As you were in the crowd, you were moving with the crowd whether you wanted to or not. In a small amount of shock, I turned back to the direction where the horse came from to see the man with the stick at it again. This time I was not fast enough to move out of the way and got slapped by the stick, which burned like a ruler as I got to the side with the others.

The next rider was off to the races and looked determined to beat the last rider's score. There were many riders that day, but I will never forget one in the middle. He had a nervous look about him as he started his ride through the people. His first arrow disappeared. I yelled out, asking the person next to me where it went, and they said, "I don't know. He must have missed the target."

I stood there for a moment before saying, "If he missed the target, doesn't that mean that the arrow went into the crowd?" The answer was yes.

There was a small circle around a child that the arrow had hit as the mother screamed and cried over their body. A group from the crowd picked the child's body up and walked with the mother somewhere in the distance.

With tears running down my face, I watched the people carry the child away. My next thought was that I would start using the safety measures provided to me, even though they didn't look or feel cool. Before this experience, I had hidden my bike helmet in the bushes a block or so from the house. Not everyone has access to helmets, and terrible accidents do happen. Just because you haven't seen one or heard of someone who died in one, they happen every single day. It was a reminder to me to not take things, including life, for granted.

∾

I spent part of my time in Tibet simply soaking in the way of life there.

It was a way for me to feel a connection with my mom, even though she had already passed. I would walk with the people daily towards the temple, some of whom had been walking for days to get there and think about the things I was grateful for and feel the earth under my feet.

Gratitude and grounding are practices that I can do anywhere, but there is nothing like being in a place surrounded by reminders (poverty and everything that comes with it) of what you do have to get you started in this practice. There have been periods when I forget to practice my gratitude and grounding daily, and my soul begins to feel lost after a while. As a reminder to recenter myself, what I have learned in this life through my own experiences and others, I have om mani padme hum tattooed on my ribcage above my phoenix. It holds me together when I struggle to return to myself ... just like my ribs.

If you look up the definition of om mani padme hum, you will find many answers. It is a mantra that is said to help you reach enlightenment if you live by it. You can hear the monks chanting it together, sounding almost like a constant hummmmmm sound. If you close your eyes and listen closely, you will hear each piece of the mantra, but if you don't listen with your whole body and an empty mind, it sounds like only one sound. I believe this is kind of the same as becoming enlightened. It is so easy to forget to listen; to ourselves, our guts, our trusted loved ones, our instincts, and others. This life is more challenging when we do not listen, yet it feels like the hardest thing in the world when all the noise stacks up.

When I find the noise getting louder, I think about my breath and my rib cage rising up and down in unison. I think about those people who walked days to get to the temple to say a mantra that doesn't have a simple definition, as the meaning must come from within you. It is a mantra that provides so many peaceful people with hope when surrounded by reasons to lose hope every day. When good days are fewer than hard days, they still trudge on ... on a path towards enlightenment. On a path toward the unknown. On a path that is centered around kindness to all. When it is extra hard, I even place my right hand over my ribcage and hum the mantra under my shaking breath until my tears turn from fear into hope. Hope for my future and

enlightenment. Hope that I will be better than the next person, kinder than the next person, and always leave an imprint on the path I took in a better place than before I walked there.

CHAPTER FIVE
THE SUMMER TRIANGLE

One of my favorite things is to look up at the stars. This love began when I was a kid. It was easy to see the stars most nights from our house. I loved the feeling that there was something bigger out there. The feeling that the stars saw more than I did and almost felt like protectors in the sky.

One day, in my early teens, Michael and I convinced my dad that we should build a deck at the top of the mountain (our property/ backyard) to sleep under the stars. He said yes as long as I carried everything up to the spot, including the water to pour the concrete, and maintained a pathway (a switchback we made) so that we could easily get to and from the deck. I agreed I would do everything. All he had to do was help me with the construction part.

My dad told me to get my muscles ready to climb the mountain with the wood, a two-person job. I showed him my biceps and took my position, ready to climb. After lots of sweating and using our post-hole digger (what we were jokingly calling a Ph.D.), we had our deck posts up and concrete poured!

The following weekend, we got to put the rest of it together and sit

proudly on top. It was perfect. It had just the right amount of room for
a large tent, and it was level with the ground on the backside, so there
was no need for stairs. You could see the house from the deck and yell
down if necessary. We took some binoculars up with us the first night
and talked through the different stars we could see.

Over the years, the deck was something I played on, a place to
retreat to and think, and so much more. After building many teepees
and tree houses, I finally helped build something official.

It was something that did not have to be taken down afterward.
Something that others saw and thought, "Oh wow, that's cool. Can you
see the stars from up there?"

An even cooler fact is that it is still there today, and it is visible
when using terrain view on a map!

About a year after my mom's passing, my dad came to my brother and
me while we were lying on the hammock on our porch and told us
that one star that was part of the summer triangle was now mom's star.
He paid to have it named after her, so we could always find her in that
constellation.

While the summer triangle is not always visible, it is always
there, shining down on us, helping us center on something greater
than ourselves. It will also always be on my wrist, in white ink, as just
small dots. Something that most do not notice or see. Something that
reminds me that she's with me always, even when the stars are not in
sight. Even today, she's within me and in the stars, the butterflies, the
warmth of the sun's rays ... watching over me.

I have gone above and beyond to see the stars at night, to see them
through the light pollution, the air pollution, and the clouds. I have
flown to parts of the world like Tromsö, Norway, Fairbanks, Alaska,
Östersund, Sweden, Reykjavik, Iceland, and more to see the night sky.
The stars continue to remind me that my imprint on this world is real,
even if it feels small at times, and even if I am one of the billions of
people affecting our planet. My imprint is still an imprint ... so what do

I want to leave behind?

I think about this often, trying to decrease the impact I have on nature for many reasons, one of which is to continue to be able to see the stars.

~

One of my favorite things to do as an adult is to plan a girls' trip (close friends from different times of my life) to wine country. I love bringing strong women together who come from different places and backgrounds, and who may know each other but aren't in each other's lives daily. I get so much joy from watching them connect on the small and more significant things as the weekend continues. Having deep conversations over great wine ... this is what I would do daily if possible.

I also simply love wine country. Napa Valley is one of my favorite places in the United States, as it is home to the big reds I love so much. Napa is easy to navigate and offers everything from small-batch winemaking tastings where the wines are exquisite (you have to know someone or know someone who knows someone to get into these private venues) to high producers of better-than-average wine served out of huge wineries that are extravagant (palaces, castles, and more). The possibilities to taste wine are endless and the adventures and memories created are magical.

One of my favorite parts of any Napa trip is being able to see the stars. Sometimes we rent a house with a pool where we can float while taking in the stars. Other times we stay at a fancy hotel that offers Adirondack chairs by firepits with stars visible above. Making sure I can take time to look up at the stars is one of the things that remains constant for me. No matter who is on the trip that year or if there is any drama going on, the stars are there for me to return to and remember my why, my dreams, and my purpose. As well as being a reminder that I am grateful to be able to get away from the hustle of day-to-day life and be somewhere where the stars can be visible.

~

I got the Summer Triangle tattooed on my wrist as simple white ink dots to remind me the stars are always there. I often find myself holding my wrist on nights I can't see the stars, knowing they are behind the clouds and the light pollution and knowing I am not in this world alone and have many fighting for me in my corner.

When I found out I was pregnant, I couldn't believe it. It had only taken us two months to conceive after the removal of birth control. I took three different brands of tests to make sure, each time holding my wrist while waiting for the test results to appear. Once I had all three positive results, I took a deep breath, remembered I was not alone, and went to tell my husband Russell our lives were changing forever. It was a magical moment, and the stars, as always, held me close.

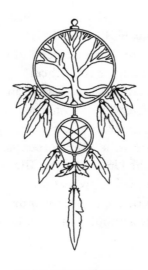

CHAPTER SIX
THE DREAMCATCHER

As a kid, I had a few tools to help me sleep at night, to help fend off the monsters in my head and the unknown ones, of course. My first tool was a stuffed animal, named Snowflake. He went everywhere I went all day, every day, and was always by my side when I slept. In my mind, he knew me better than I knew myself, and he was my rock. I spent my first night without him as a preteen ... it was a very difficult night. More on Snowflake later.

My second tool was my dog, Pepper. We got Pepper when she and I were three. We were the same age, had blue eyes, and were both stubborn! She was a perfect fit for our family. She had some inner scars from her early years and was a little rough around the edges, but she was a really good dog. Loyal and smart as can be. Pepper would sleep in my room under my bed, always making me feel safer. She made us all feel safer even throughout the day unless I was annoying/poking/ prodding her, to which she would respond with a warning growl or bark, and I would respond with tears. Pepper taught me a lot, including how to be gentle with animals.

The third tool was my dreamcatcher. I had various dreamcatchers

over my early years, some of which others had given to me as gifts and some of which I had made. I loved them! They were all unique and beautiful. They came in different shapes and sizes, in different colors, and had various things hanging from them.

My mom taught me that Native Americans first created them, and people hung dream catchers by or from their beds to capture anything that could cause harm. Later in life, I learned that they originated in the Anishinaabe culture—the Ojibwe people who were indigenous people in Canada and the United States. They were meant to replicate a spider's web and were used to protect infants. Other tribes eventually adopted dreamcatchers through the Pan-Indian movement, and by the 1980s, they had become a popular native craft for all to buy.

∽

I do not believe in organized religion. I grew up in a place where religion was very present for most people around me. I had the chance to experience many different religions, churches and practices through friends, but it was always on a "curious to know" basis to understand a friend's deeper quest and not a quest for myself.

I do, however, consider myself spiritual. Through my spirituality, I believe we can connect deeply to things that may not be tangible. I believe if you look close enough, you can see how the grass shifts when you are close by, how the tree breathes with the wind, and even how the presence of a spirit may feel when close to us.

I have had a few intensely spiritual moments that have helped me, in various ways, reconnect to myself and my values.

∽

The first happened while I was playing soccer. I was a striker in soccer—it was what I was to my core. I had zero interest in playing any other position, and my coach knew it. I was medium good at soccer, always on the highest of competitive teams, and always a starter through high school, but I also had some bad luck with a few injuries that kept me from continuing to want to play in college. I knew that soccer wouldn't

be how I made a living, and I wasn't interested in balancing playing, partying, learning, and how my knees and ankles already felt.

There was a game in high school, long before my first tattoo, where my coach decided I should play goalie. He wanted me and the actual goalie to get a different experience and stretch ourselves. I was livid and argued with him, but eventually found myself standing in the goal. I was bored, luckily, because our team was pretty good, so I was getting angrier about my position by the minute. Suddenly, as I was contemplating what the consequences would be if I walked off the field, a butterfly flitted past my head. It surprised me so much that I swatted at it initially, not knowing what it was. It dodged my hand and landed on my glove for a second. It took me from being entirely not present, unaware of what anyone but me was feeling, to totally focused on this beautiful butterfly.

I can't explain how, but I could feel my mom's presence at that moment; it was like she was the butterfly. It made me calm down, take the position change as a learning opportunity, and help the team achieve a win from the goal. I took a deep breath, and the butterfly took off from my glove ... like it had delivered the message and went behind the goal to do what butterflies do, I imagine. I can't say that I changed my mind about my preferred position on the field, but I can say that I stopped a couple of goal opportunities from the opposing team and was a team player for the rest of that game.

∼

The second was while I was at a friend's house. My best friend, Emily, and I felt as if we basically survived off sleepovers and whether we were able to have one or not. It was like they were the key to our happiness and belonging on the planet in junior high (grades seven to nine at my school). Having a sleepover was difficult on Saturday nights because she grew up going to Mormon church every Sunday morning. Church was long, so I wouldn't typically wait for her to return. We somehow convinced both of our parents it was okay one Saturday night and that I would sleep in and wait for them to return from church. I was home

alone and excited to sleep more as we had stayed up super late chatting/
giggling/dancing and binge-watching Channing Tatum movies. She
had three siblings, so getting ready for church was much louder than I
expected, with lots of running around and yelling for things. So, I was
wide awake by the time they left.

It was almost eerie after hearing their car pull out of the driveway,
quieter than the house ever felt. I was so excited to sleep! I laid back
down on Emily's bed in the basement and closed my eyes. I must have
slept for a few minutes, but then I woke up with a start. The kind of
wake-up where you are not sure what woke you, but you are on full
alert. I sat up in bed, trying to figure out what had woken me up.

The house was still silent, but I did not feel like I was alone. It was
an odd feeling because I also didn't feel fear like you sometimes do
when convinced something terrible is about to happen. I was calm and
okay with the presence. I sat there in bed for several minutes, just being
with it in silent thought. I did not pick up my phone to distract myself
or turn any music on ... I just sat there.

After a few minutes, I felt a sense of gratitude and peace from the
presence. It was then that I knew it was Emily's father, who had passed
a few years prior. I had never met her dad, but I had heard fabulous
stories, and I knew without a doubt it was him, just saying hi. I smiled
and laid back down, closing my eyes again for a nap before Emily and
her family returned.

∽

The third was while walking the streets of Lhasa, Tibet, checking out
the flea market, and taking in the people and culture. A boy stopped
me. I had never seen or spoken to this boy before. We were standing
within a block or so of a temple, and he was wearing robes. I had been
feeling sad, the kind of sad you feel, even though you are not sure why.
I didn't think I was showing how I was feeling, but I wasn't trying to
disguise it from others, either.

The boy looked straight into my eyes, but with soft, knowing eyes,
it was like he was a messenger. As he handed me a small picture of a

Buddha, all he said to me was, "Your mom, Linda, is with you always."
I took the picture from his outreached hands, gasped for breath, and
before I could speak, he was gone. Just like that, he disappeared into
the crowd, and I was left with a small Buddha photo and a profound
reminder that those we lost are always with us in our memories and
hearts.

~

Not all memories are happy ones. Many are of dark times that we have
pushed into the deepest holes of our memory to protect us. Sometimes
they are memories of real people we once knew and don't want to know
anymore. These memories and people are lessons, and they shape who
we are today. I believe there are physical scars, mental scars, and even
scars that we don't see or feel until something triggers us (i.e., ghosts of
our past). I have plenty of these scars from my life, and I have done lots
of work (therapy, building self-awareness, and leadership development)
to live with them in harmony instead of fighting against them or hiding
from them. It isn't always easy, but it has always been worth the work.

One of my ghosts is someone I knew to be called Edward. I met
him when I was sixteen through my friend, Elizabeth, via instant
messenger. Instant messaging was new at the time, and there were fewer
fears about communicating through the Internet than there are today.

Elizabeth told me she had met Edward and his friends in person
and that I would like him.

So, I chatted with him online and got to know him. I shared my
deepest, darkest secrets with him. I talked to him about my mom's
death and how much my friends and family were driving me crazy. He
was the first person to ask me to be his girlfriend. I was ecstatic; he
made me feel seen and heard in a way I wasn't used to feeling. He made
me feel loved.

Things never got weird, outside of him never saying yes to meeting
me in person (per my request). He never asked me for photos or pushed
me to have discussions about things that were sexual or anything of the
sort. My friend, Elizabeth, supported us by cheering on the relationship.

Months later, Edward's friend (who I had also chatted with via instant messenger) came online and told me that someone shot Edward and he was dead. I cried and cried and drove to Elizabeth's house and cried some more. We had been told that there was some gang association, and that Edward was stuck doing things he didn't want to do for the gang. She and I mourned that day and slowly tried to get things back to normal (sans Edward). After several weeks of me not "getting over" Edward, Elizabeth turned to me and told me she had never met him and that she had told him to leave us alone.

I cried and looked at her with pure hurt. She lied to me and made me believe things that were not true. I could no longer trust who Edward was or who he was not. I couldn't hold on to all the many feelings I had for him. I also couldn't trust Elizabeth, a friend I had known for more than a decade at the time. She had lied to me and strung me along in a situation I would have said no to being in otherwise. It was a deep wound that scarred our friendship for many years after.

Today, I look back on Edward, and believe it or not, I am grateful. Regardless of who Edward was, they helped me process things in a healthy way (through writing) that I am not sure I would have processed myself as quickly. They gave me confidence that I did not have before, and most importantly, they never harmed or hurt me. The bottom line is that this was a completely inappropriate relationship at every level.

We will never know who Edward really was, but all things considered, I ended up incredibly lucky and safe.

~

I got a dreamcatcher tattoo to capture the wisdom I feel I have from my past. It is a large tattoo going down the side of my ribcage to my upper thigh. It has three components: it is a dreamcatcher; it includes a tree of life; and it includes an atom all within it. Each component holds meaning for me and makes it mine.

I feel my dreamcatcher tattoo captures all versions of spirits and ghosts, and I am safer with it protecting me. I can face them when and how I want. I am proud of my spirituality, scars, and ghosts, and I

continue on this journey we call life with my head held high.

~

In the center of my dreamcatcher tattoo, instead of a typical web, I have a tree of life. I have branches and roots extending out to the round wall of the dream catcher. It is a knotted tree without leaves that exemplifies strength. It isn't the standard definition of beautiful, but it is a reminder of stability and the rawness that life can be in certain moments. The tree of life symbolizes many things. It is hard to find the original story of the symbolism online. I was told when I was young that it was a symbol of protection, stability, strength, and power. The tree of life is a reminder that life has its ups and downs. You may have assumptions about how the world works, but you also have the choice to branch out and expand yourself in the ways unknown. One needs to expand one's branches to get through ups and downs, stand tall and remain positive.

I chose to have the tree of life in the center of my dreamcatcher because my roots are deep, and my branches grow strong. I am an ever-evolving human, and my strength comes from where I've been and where I have yet to be. It is a reminder that I am a survivor of lots with the ability to get through anything that comes my way.

~

During my tattoo interview with the artist, he asked me many questions about what I wanted my tattoo to be. He got to know me, where I came from, and what I did for a living. One of the things he learned was that I had recently graduated from nursing school, and I was studying for The National Council Licensure Examination (NCLEX) to become a registered nurse. When I returned to see the drawing he had created for me, he included a second layer to the dream catcher with an atom orbit symbol. I loved it. It was unexpected but still captured a part of me. It added to the dreamcatcher in a powerful way, and it fits on my body in all the right ways.

Science has always had a prominent place in my life, whether I've been working in the healthcare industry or taking care of my mom or

brother. It has been something I can hold on to and learn from, no matter what. Science is something that you can trust, and that is always evolving. It is both fascinating and frustrating. It can be used to protect you ... just like dream catchers.

~

Today—my dreamcatcher continues to provide me with reminders. It helps me sleep at night. When I'm having trouble sleeping, I put my hand to my side and breathe deeply, knowing that I am protected by more than me. By the things I know for sure and the strength I have within me. I can weather storms and stay strong through them. I can be present and open to the world through my frustrations. I can believe in more than just myself and grow into my future self with intention.

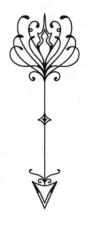

CHAPTER SEVEN
THE ARROW

My mom was one of five siblings; three of them lived in San Diego when I was growing up. One of her sisters had a daughter named Amanda, who was about one year older than me, so naturally, we became close. We saw each other as much as possible, between one and two times a year. Amanda emulated the best; she was intelligent, beautiful, and had girl power like the best of us.

Amanda and I spent a lot of our time together dreaming. We created a scrapbook (or three) of our childhood time together and our family events. We rode horses, made ice cream, and created synchronized swimming routines, and planned out every detail of our future ranch that we wanted to have together. We wrote down what we would do for a living, at what age we would marry, how many kids we would have and when, and how our houses would connect so that we could quickly get to each other even though we would live with our partners and children. It was our future ranch, and we knew we would get there one day.

There are many memories of our deep connection, but one funny

one is when we were on a beach one day—inseparable as always. We were swimming, building sandcastles, running around doing all the things. At one point, we decided that being in the sand was better than being on top of it and started burying ourselves. We continued burying (making sure we could still get up when we wanted), with help from our siblings, all but our heads. It was lovely; we were nice and cool with the sand between us and the sun, and chatting as always. Our families started calling us Samda (making one name for us in combination). From then on, when we were both together, it was Samda for short. Of course, there is a photo of just our heads with our bodies buried in sand in one of our scrapbooks.

Once we entered our teenage years, things shifted a bit. Amanda was more into fashion and boys, and I was into sports and friends. We would still chat often and beg our parents to let us get together. The older we got, the more different we became.

There were parties and people that we did not see eye to eye about. When I was seventeen, things took a real turn in our relationship. Amanda was in college, and I was still a senior in high school. The way we partied was different, and how we felt about the boys in our lives also differed from one another. We were still close, but the shift was clear to me then.

Over the holidays, my family visited her family, and she was very focused on her boyfriend. We barely saw her the entire trip, and the whole situation created a lot of weirdness.

After that trip, it was a long time before we would next meet up.

Several years later, she came to visit me in Austin, TX. I had recently moved, and she was living in Chicago and attending grad school. We got plenty of one-on-one time and tore up the town. It was like none of the weirdness had happened, and we were as close as ever.

We decided on that trip to get tattoos together. The shared design would be something beautiful and represent our forever connection. We landed on an arrow, which would run down our spines. When

asked what it meant, I would say, "It means that we can always count on each other to help point us in the right direction." She would say, "We both just liked it." Our difference in answers might have been a first symbol of how much we had grown apart over time.

It was a beautiful arrow, and regardless of what either of us thought it meant, to me, it symbolized the magic of our kind of bond. Our friendship was something I couldn't live without at one point, and it was something I could count on through good times and bad. Our bond made me feel like another person understood me and that my dreams were reachable. It was the first tattoo I got with someone else, and I knew that no matter how old we became or how much we talked, our arrow would represent that kind of deep connection you can have with another person. And it was beautiful!

Wanderlust

CHAPTER EIGHT
THE WANDERLUST

One of the many things I appreciate about my childhood and how my parents raised me was that they were always genuinely curious about other cultures and people. Others knew my mom for this especially, as it showed in the people she surrounded herself with and the people she affected during her life.

During my mom's celebration of life, there were people in attendance who had only met her once (i.e., in a grocery store or on a plane). Some people had spent more time at the celebration of her life than they did with her! The support and imprint that she made with everyone she encountered throughout her days was amazing.

People still get emotional when they find out I am her daughter, and they share their memories of her with me. They all highlight how much they enjoyed knowing her for however long they did.

I always aspire to be just like her in this way.

My dad grew up in Roanoke, Virginia, and his upbringing exposed him to more than most typical southern men born in the 1950s. His family was an upper-middle-class household filled with genuinely good people. His parents were church members and believed in treating all

people with kindness.

My grandfather enlisted in the military in 1942, working in the 317th air transport squadron. He tried to keep planes in the air by "patching" or repairing them daily. He was engaged in some battles, but mainly worked on keeping aircraft flying. As many people experience after going to war, there are ways it shifts perspective in life (what's important and what's not), and I believe that was true for my grandfather.

After the war, my grandfather worked as a physician and ran a clinic in Roanoke. In this clinic, he cared for patients of all backgrounds and treated them equally and kindly. He even traded care for things that were not money, like meats and veggies! This rubbed off on my dad, and he helped shape me into the person I am today, a person who is curious about other people, regardless of background or culture.

Between the two of them and traveling together as a family, I was able to experience and see all kinds of cultures and people. I expanded past my canyon cabin in Salt Lake City, UT, to dream more extensively than I may have done before, knowing that there was so much in this world to explore and see.

I have also been able to do a lot of solo travel, which helped shape me into the woman I am today. Three trips stand out as pivotal to my growth and development.

In Tibet—I was a witness to how little some people have and how dark the world can be. I also saw how beautiful humans are and that we are much stronger than we may know, especially if we help each other. I learned/reaffirmed to treat people like friends first, without judgment or assumption, and with an awareness of what biases you may have, moving through life holding awareness and intentionality. Live life for today—meaning being present with what's going on and who is around you. Make the most of the day and who you share it with. Build others up whenever possible. It is amazing what a simple smile or hug can do to shift someone's trajectory.

In Guatemala—I was a witness to the complexity of providing care to all who were in need. I learned that crime and violence could take over a city and leave a mark on it in a way that is much greater than fear.

I confirmed that helping people was what I was on this planet to do. I saw that there is beauty still within darkness and people who are good, even when surrounded by danger and fear. People can be mighty when they come together. Even though we may not be able to help every single one of them, many need our help in what ways we can provide, and they are grateful for it.

In Europe—I was backpacking solo, leaning into who I was and who I wanted to become. It was freeing even when scary. Knowing and accepting oneself (flaws and all) can only create more opportunities. There are different types of good and evil in the world, and becoming aware enough to know the difference is something I hope to teach my children. Saying yes to adventures is rarely something you regret.

Travel is a core value of mine. It has helped me through the toughest of times and taught me more than any degree I received. I was lucky enough to travel the world with my family, starting at a young age. We went all over the world, mostly visiting friends or following work conferences where my dad was speaking as a guest or keynote speaker. We went to Italy, France, London, Australia, New Zealand, and other countries, all before I was sixteen.

I want to travel to all corners of the world, see what people love to do daily, seep into all the different cultures, and learn how people connect to themselves and others. Though I may walk away saying, "Nope, not for me," I can proudly say I will try anything before deciding, except for certain food restrictions I have placed on myself. For these, I am greatly unwilling to explore and willingly know that I am missing out.

~

In college, there was a Thursday night routine that many of us had. It was dollar beer night at the local bar, followed by dancing two blocks away in a dark basement bar. It was a ritual that was like going to church for me. I would hold on to all of life's stressors and make it to Thursday night, when I knew I would get to talk, connect with my friends, and then dance the night away. I had a fantastic friend group in college. I was lucky enough to make some lifelong friends and, of course, some

who would end up being shorter-term connections.

I met one of the people I became close to in college while out dancing on a Thursday night. Ashley was bubbly, fun, loud, and blonde, just like me. She was a boundary pusher. She rarely said no to anything and always jumped into things headfirst. Ashley and I did all kinds of things together that were arguably questionable. We would party later than we should for what we had to accomplish the next day. We would kiss the person if we wanted to at that moment. We would live life for that day all the way. It was like everything we wanted or had an inkling to do, we doubled down on and did it. We would support each other without worrying about the cost. Truly taking living in the moment to a whole different level.

She and I had a beautiful friendship, but it was a bit unhealthy. We put ourselves in several dangerous situations over the years we knew each other. Luckily, we never got hurt or arrested or worse at the end of the day. Nothing stopped us from taking on the world and whatever opportunities that came with it every day we spent together.

One weekend, Ashley and I traveled down to Virginia Beach to meet up with an ex-boyfriend of mine. I knew this was not a good idea and had shared with her why it wasn't in great detail. He and I had been in love, and our relationship was serious, and it had ended badly, hurting us both. He wanted to get married, and I wanted to wait. I felt I was too young at nineteen, and that I still had some living to do before settling down. I ended things one night suddenly because I knew I couldn't be with him anymore. I knew I would not be ready anytime soon for the level of commitment he wanted us to have. I kissed someone the night I ended it, knowing that if I didn't, I would likely go back to him and apologize. I ended up doing just that, but with the added weight of kissing someone else. We tried to make things work short-term and ended things more officially a bit later.

My ex and I had not seen each other since our final ending, and it didn't make sense that he invited us anywhere. As usual, Ashley said, "Let's go!" and off we went. She knew I still had a deep sadness about how our relationship had ended, but as always, we were jumping in headfirst. We spent twenty-four hours with my ex and his friend. It

brought back a lot of wounds and feelings that neither of us had dealt with.

The four of us were playing a version of beer pong that involved dares at his friend's house, that was on the way back to Northern Virginia from Virginia Beach. His friend tried to make a move on me. Surprised and confused, I looked to my ex for a reaction, and he looked down at his drink, not even blinking. It became clear then that this was not a situation I wanted to be in. He was no longer in my corner as someone who had my back, as I had broken his heart. This was closure for him and nothing more. I knew then we needed to leave.

I grabbed Ashley, and we got in the car and left. I sobbed and let go of every wound I had not healed from our time together. I was losing hope for my future and my ability to let love in, including love from myself. I loved him deeply and hurt him deeply. I was ashamed that the relationship had ended the way it had while also knowing that it was not the right path for me at the time.

There was a part of me that was upset with Ashley. I couldn't believe that she had pushed me to put myself in that situation and did not protect me from myself or others. Instead, she doubled down like she always did, which hurt me significantly this time. Ultimately, knowing that I could have stood up to her more strongly and said no to going. Knowing that there was a part of why this mini trip happened that I was in control of had I chosen to be. Ashley was just being herself, the same person I considered such a fun friend. The same person that I had lived in the moment with on many other occasions. The relationship overall didn't benefit who I was trying to grow into or what I wanted for my future.

There is a part of me that wishes this experience had felt like closure—but it did not; it felt more like pouring salt into an open wound. To this day, I look back on my ex and remember he was a fantastic human who I hope is happy today, but I do not regret staying true to myself and waiting for marriage because I wasn't even close to being ready. Sometimes people don't connect at the right time; unfortunately, it can be that simple.

I pulled away from Ashley after that without much explanation.

She spontaneously decided to move home to San Antonio within a couple of months after that trip. Before she moved, our last night together was another Thursday night dancing, just as we had done many nights before. We continued to stay in touch by phone, though our relationship did not feel the same as in person. I became more responsible and hesitant to connect with her, not trusting myself fully when I was with her, not knowing if/when to stand up for me because sometimes it was more fun not to.

I eventually moved to Austin after graduating from nursing school. I chose Austin because I had heard it was a fun city that was also affordable to live in. I was searching for a job and was ready for a fresh start. Also, I was tired of living on the East Coast. Tired of the traffic, memories, and politics.

Once I got to Texas, Ashley came up to visit for the weekend occasionally, and we quickly fell back into a routine when she was in town. Things were a little different then, but not by much. We still lived life on the edge and did things spur of the moment. One day, we decided to get tattoos. I knew this was probably not a good idea unless we got something that I loved with or without Ashley in my life. We started brainstorming ideas about what we wanted, searching the internet, and talking about just about everything we enjoyed doing in life.

We decided to both get the word Wanderlust as a tattoo. Wanderlust means the strong desire to travel. We had it tattooed in simple script text on our ribcage. The tattoo wanderlust represents one of my core values in life (travel) as well as what Ashley represented to me (living in the moment).

Ashley and I eventually did have a big falling out. It was one of the most dramatic endings to a relationship I have had to date. Which, of course, felt right for the kind of relationship we had.

We chat via text occasionally now, but we are not close anymore. She will always be someone I look back on and have many unforgettable memories with, but it is probably best that we have gone our separate ways as I never feel truly seen by her ... she is a person who knows my

deepest secrets but does not always hold space for my feelings around them.

∽

I am still living life to the fullest through travel and being where my feet are. My amazing husband and I met at the Seattle airport! We were both looking for a quiet place to work for conference calls and ended up sitting kitty-corner from one another for a little over an hour. We both got off our phone calls almost simultaneously, and he remarked to me about the Wi-Fi. I, unknowing of his intentions or what he did for a living, offered help, which is now hilarious as he is in tech and was simply trying to talk to me. We had a conversation and exchanged emails. I thought he was cute but also did not think I would ever see him again as he had just moved to Dallas, and I had just moved to Seattle.

About a week later, I got a ping from my work security desk asking me to come to pick up my flowers. I responded with, "What flowers? You must have the wrong Samantha." I thought through every possibility and decided that there was no way anyone I knew would send flowers to my work.

The security guard said, "They are for you. You are the only Samantha Branch (my name pre-marriage) in our system. Please get them ASAP."

As I walked up, there was a beautiful orchid with a card attached. I confirmed who I was and took the orchid to my desk. I pulled off the card with my team surrounding me, reading it to myself, and then aloud, "Sami, I hope these brighten your week the way you brightened mine. Russell (123-123-1234)."

My boss yelped, "Who is Russell?"

I sat there for a minute, racking my brain. *Russell, Russell, Russell.*

"Oh!" I said. "The guy from the airport!"

I had given Russell my work email, and it gave him enough information to track down where to send the flowers. It was so sweet! I decided to text him to thank him since it was still the middle of the

workday; as soon as I set the phone down and turned back to my team, my phone rang.

I looked at the caller ID to see Russell's number calling me, and I gasped and said, "It's him!"

Everyone screeched, and my boss pushed me into her office to take the call (with some privacy).

I said nervously, "Hello."

He said, "Hi, Sami. I figured I would call to get the first awkward phone call out of the way." And the rest is history.

What have I learned? Trust your gut and let love in, even at times when it feels odd, too, for love is what provides hope and belonging. Love is one of the greatest and most powerful emotions. Being partnered with someone you respect and love profoundly and receiving both in return is beyond worth it. I am forever grateful to my travel bug and my strive to always live in the moment because they are both responsible for me meeting my now-husband.

My challenge for you, if you're reading this ... is to say yes to the next big adventure someone asks you to join or even the next big adventure you think you want to do alone! Do not let fear stop you, unless it is something that doesn't feel safe in your gut (always trust your gut). Figure the cost of it out and explore something magical. Sometimes the journey of getting there can be as rewarding as being there. Be where your feet are, with your heart and mind open. Soak it all in.

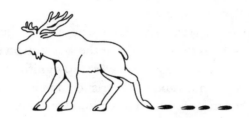

CHAPTER NINE
THE MOOSE

Access to nature helps me ground myself in hard times.

I grew up living in a canyon in Salt Lake City, Utah. Nature and wildlife were deeply rooted in my spirit. Leading up to the canyon head was the local zoo, as well as a few other known landmarks of Salt Lake City. It was a residential canyon—meaning there was not a ski resort at the top of the canyon, and it was home to people who lived there year-round, but otherwise not much of a used canyon compared to others nearby.

It was a long walk or a twenty-minute drive. It felt like a lifetime when you were ready to get somewhere, and, at the same time, it felt like a blink of an eye when you were present with the road only. The drive was beautiful, windy, and raw in all the right ways. You could still pick up speed while also being forced to drive slowly enough to give credit to the mountains, as there were big turns and warnings for falling rocks.

With the wilderness came wildlife. Animals like coyotes, moose, porcupines, wolves, and mountain lions surrounded our property. We lived intentionally in nature with these incredible animals. My favorite

of them was moose.

They are massive, tall, giant beasts with a considerable presence in feeling and literal form. They are regal, strong, and awkward—all the things. I am still in awe of them.

One day I woke up late to catch my school bus—the bus picked me up at 6:30 a.m.—I was the only rider at the first stop on the route. I was never late because the consequences were too significant for me to miss the bus. The driver, Sylvia, and I were friends, and because I was the first stop and she liked me, she would give me a two-minute grace period.

I knew that if Sylvia saw me running down our steep mountain driveway, she would wait. It had snowed that day—a lot ... going all the way up to my knees—several feet of fresh powder overnight. The snow confronted me at the front door. I sighed because I knew there wasn't time for me to get my snow gear on and get down to the bus on time.

I took a deep breath and started walking like a cat walking in the snow (lifting my legs high and trying not to get my pants too wet). Suddenly, I heard a low rumble deep in something's throat coming from close by. I froze, not knowing what was happening or where the sound was coming from, or from what animal/person/thing. I slowly looked up to find myself face-to-face with a large male moose standing within arm's reach. I tried not to make eye contact (which they can consider threatening) while shuffling back towards the front door, not bothering to lift my feet anymore. Snow be damned.

I got back inside the house, my heart pounding for two reasons. First, the moose could have decided to hurt me in a split second. Second, I had to tell my dad I had missed the bus. The only thing worse than missing the bus was missing the next stop.

My dad's room was up a set of wooden stairs, about sixteen stairs high. It was a tall staircase and straight-up hardwood. I sprinted up the stairs and woke him up as quickly as possible.

"Dad, I missed the bus. Hurry!"

He started yelling at me, as expected, but got up quickly. I began to move back down the stairs and slipped as soon as I hit the top step.

I hit the stairs with a bang, falling down all sixteen stairs. I laid at the bottom, assessing if I could stand up or if I had broken something—

with our two dogs crouched over me, also checking to see if I was okay.

My dad had run down the stairs, not because I had fallen, but because we needed to catch the bus. He yelled, "Get up!" and I stood wearily to my feet. Sore already, but committed to righting my wrong and making things better for my dad.

We got in the car and went to pull out of the driveway when the male moose was standing tall in the middle of the driveway, making it impossible to get around him. Unmoved by our persistence or yelling, he stood staring at us like nothing mattered more than this moment, and he was unphased by all the swearing my dad could do.

We missed the first several bus stops that day—but there are a few lessons that Moose helped me learn. Even with all the planning, preparation, and persistence, sometimes things just don't go your way. Sometimes it's through our need to pivot that things become clear. Sometimes it's worth slowing down to speed up. That Moose stood tall, non-reactive to us no matter what ... continuing on his path for the day unapologetically.

Moose were a part of my childhood in all the right ways—regal and strong. Some lessons I learned from Moose were harder to learn:

- Don't get in between a mom and a baby, no matter what. There is nothing like a mother's wrath/fear.

- There are days when you will need more time to get to the bus—being on time out the door can still lead to you being late.

Others were wonderful lessons to learn.

- Humans can coexist with marvelous animals and should always respect one another. No, the world does not revolve around you.

- Often things are bigger than us around each corner—keep your awareness high and imprint low.

Moose, to me, stand for strength, being able to go through storms

and make it out the other side. They are magnificent creatures that are just stunning to see in the wild. I have a moose tattoo to help me stand in my strength, even with my scars.

This tattoo is a watercolor tattoo, four colors, each starting from a footprint behind the moose that is then painted across the moose's body in a watercolor effect. The moose is me, and the footprints are Jacob, Mom, Laura, and Liam. These four people changed me in different ways, but all had a lasting mark on my soul.

"Unable are the loved to die, for love is immortality."
—Emily Dickenson

~

Jacob Brown was a huge part of my early childhood. My mom and dad rented space from him when they first arrived in Salt Lake City, Utah. The three of them became fast friends. Jacob was in a wheelchair as a result of having polio; he had long gray hair and a long beard. He always wore lots of jewelry, rings, chains, and bracelets. He laughed with his whole belly and never complained about his wheelchair. He was one of the best humans I've known. He was always around when I was young, whether it was to babysit or to chat about life with my parents.

One of the funniest memories I have of Jacob was when he decided he would have a yard sale. My mom, Michael, and I offered to help to set up the things that he was parting with that day and help him sell. There was a table of all kinds of treasures, old coins from around the world, stamps, and trinkets. There were thingamabobs galore.

While setting up, I found a few things I just had to have! They were in the ten cents section, and I was very excited. At this time, I was old enough to know I needed money to buy the items at this time, but not old enough to have any of my own money. I ran up to Jacob and asked him if I could borrow thirty cents. He wheeled over and checked out what I had my eyes on, found thirty cents from his pocket, and said, "Of course!" I jumped up and down and ran to the payment place. Jacob wheeled around so that he could receive my payment. He

counted each item and checked the price, just to be sure. Ringing me up like he would any other customer.

He said, "That will be thirty cents, please."

I handed him my three dimes with a grin. I turned and ran to show my mom what I got.

She said, "Wow, Sami. How did you pay for these?"

I said proudly, "I asked Jacob if I could borrow thirty cents."

Jacob chuckled from his belly, and my mom laughed, covering her face with her hand (her signature laugh at the time).

I turned from one to the other and smiled, saying, "What? What's so funny?"

When they were both finished laughing, my mom asked how I would pay Jacob back. I thought hard about this and told Jacob I was willing to work for the money. We talked about what kind of work I could do for him. Eventually, he and I agreed that I would pay him back by helping put everything in its proper place at the end of the yard sale (even though this was likely something we were going to do anyway in hindsight).

Jacob moved to Hawaii when I was around nine. He wanted the island lifestyle. I have pictures of my brother and me dancing naked on the beach, with our parents and Jacob in the background.

Jacob died a couple of years later, likely from the accumulation of health complications. He would tell you that he lived his life as a grand adventure and had no regrets. He will always be in my heart and a part of me. I have many gizmos, art, and jewelry that we inherited from him that I love. My memories of him are wonderful; he taught me so much over the years that I knew him.

The color orange throughout my moose tattoo represents him, and it is the first footprint of my moose.

～

When I look back at my time with my mom when I was a kid—I look

back in awe at how much of an imprint she had on my life. She taught me to lead a life full of passion, with my eyes and heart open to all. She also taught me to love deeply, starting with myself.

One story from my childhood that stands out as a significant teaching moment was a day on a horse with no saddle. I'm not sure what took us to this ranch on a sunny day in Utah, but I left there feeling different from before. Wiser even.

When we arrived at the ranch, there was a woman my mom seemed to know by the name Kara, but Michael and I had never met her before. She greeted us with a warm smile and asked us if we were excited about the day. We said "yes!" and meant it—though we did not really know what we were there to do. My mom said the mission was to connect with nature, ourselves, and a horse.

All three of which we loved.

We walked out to the stable and met the horse we would work with for the day. It was only one horse—a kind of older horse. Tall but not too tall, a brown brushed coat and kind, knowing eyes.

Kara put a harness on the horse, and we all walked out to the far end of a fenced-in field to the shade of a large tree. The three of us, Mom, Michael, and I, all lined up against the fence and listened as Kara talked about the importance of connection. We talked about what it feels like to be in connection with ourselves and others. We talked about the things we could feel connected to, like the trees, our dogs, and each other. We explored how open our hearts and minds should be to let in connection. How being afraid or anxious may negatively affect our ability to connect deeply.

Then we took turns asking the horse permission to approach and get on his back. We did so with our bodies and voices, practicing being calm in movement and spirit. Building trust before getting on his back. The horse allowed us to each ride him bareback and without control. We walked where he wanted to walk and lay flat on his back, looking up at the sky, surrendering to the trust and connection of the horse. We felt our heartbeats align in rhythm and connected deeply to the horse and ourselves. Connecting and appreciating the tree-producing shade, the wind, and the birds singing songs as we enjoyed our time outside. It

was a beautiful experience, one that I know now that few people have.

I am not sure if we ever voiced to each other how much that day impacted us, but I think my mom knew that if we let it—it would help turn us into good humans. I look back on that day and reflect on how much it continues to impact my leadership and my sense of things around me. It was a powerful experience that continues to help me slow down when life gets busy around me.

For this lesson and many others, purple represents my mom and is the second footprint of my moose tattoo.

∼

After my mom's death, I would say that I regretted only one thing. There was a day that we had planned for a long time where my mom and I were supposed to go on a girls' day shopping trip.

However, I told my mom that we needed to reschedule our shopping trip because a new girl in school had invited me to a family party and sleepover. I begged her to let me go and told her all the reasons it would help the girl settle into our school and would be a blast. I was in sixth grade, so Laura joined our class at a weird time (the last year of elementary school).

My mom, of course, said yes, supporting my mission. I went to Laura's that day and spent the night. The next day, I came home and reported to my mom that Laura and I would probably not be very close. We had little in common, and I didn't have as much fun as I had hoped. I did not feel like my mission failed, but it also hadn't gone quite as planned.

After that sleepover, though nothing crazy had happened (like a fight or something), neither of us pursued a deeper friendship than simply being classmates. Laura and I always said hi to each other even when we moved on to Junior High and High School, but she found a different friend group, and we didn't hang out one on one again.

My mom died before we could make that girls' day shopping trip happen, so I regretted begging her to change our plans so that I could have a play date with Laura. I was trying to live with no regrets and

disappointed myself for taking the time I could have spent with my mom and spending it with Laura instead.

Several years later, when we were in high school, Laura died in a tsunami while traveling with her family. I couldn't believe it—my one regret I could no longer see as something to regret. If I hadn't gone to Laura's family gathering that day, I wouldn't have welcomed her to her new home. I wouldn't have known if we could have been good friends. The party was a big deal for her to have a friend, or potential friend, attend. She invited me because I had been kind to her when others weren't. I reached out my olive branch and she did the same.

The lesson in this one is weird because the circumstances are inconceivable. What I can tell you for sure is that living with regret does not serve the person you are today or the person you will be tomorrow. Finding a way to forgive or apologize for things you may regret is a healthy step to setting yourself free from your past.

The green footprint of my tattoo represents Laura. She is the third footprint of my Moose.

~

When my father remarried, Michael and I got two stepsiblings, Liam and Ava. Liam was only five days younger than me and was an extreme extrovert like me, and Ava was a couple of years younger than us and one grade older than Michael. They both attended the private Catholic high school Michael would attend.

I attended a public school in the area—wanting to stay with my friends and loving the soccer team I played with at the public school. Since Liam and I went to different schools, that meant that we had multiplied the number of seniors we knew or could know.

Often, I had friends over, and Liam had friends over—all the same age and very interested in getting to know each other. We were both extroverts, always surrounding ourselves with people and always down for any social activity.

One memory that stands out to me happened during our senior year of high school, several days after I had been through a breakup

with my serious (everything feels serious when you are a teenage girl) boyfriend. I had parked myself in the television room watching romantic comedies back-to-back, eating ice cream and feeling sorry for myself.

Liam came into the room and said, "Hey, Sami. I'm thinking we should throw a party together."

I looked at him with questioning eyes, and he said, "We gotta get you back out there—you're young and beautiful, and he's an idiot; let's go! "

I agreed to rally, and we started calling our phone trees, getting everyone there within only a couple of hours. We had people who had fake ids or older siblings assigned to bring certain types of alcohol; we had people bringing cups and ping-pong balls. We had access to his biological father's house (who was out of town). We were unstoppable. He waited for me to get ready and for a couple of our closest friends to arrive, and we drove to the house.

Within about an hour, the party was clearly out of hand—we had more people than we knew what to do with and did not know many of them. Liam and I agreed to start kicking people out that we didn't know. We walked around the party, asking people who they were as we tried to get a handle on things.

A few minutes into our efforts, one of Liam's friends ran in from outside, screaming, "The cops are here, the cops are here!" Liam and I started moving faster around the room, taking people's cups from them. We knew that we were about to get busted for underage drinking at a minimum, but we thought we might be able to reduce the damage by hiding the evidence of underage drinking.

We got around the house and collected all the solo cups, placing them in black trash bags, then the house lit up from all angles. The police had made it so that people who were trying to run away could no longer do so without being seen (and then caught). Liam and I, looking out of the window, realized that there was one stray solo cup outside on the table. We looked at each other.

He said, "I'll go grab it, throw it to you, and run back. We got this, Sami."

I nodded and held the trash bag open by the sliding door he had just exited. He grabbed the solo cup off the table and threw it over his shoulder—as he was pivoting around to come back, a cop tackled him to the ground, yelling. I caught the solo cup, put it in the bag, and slid the door shut while making eye contact with Liam (as his head was being shoved onto the pavement).

He tried to take the fall for everyone in the house as the police officially arrested him. The cops eventually gained access to the house by getting permission from Liam's dad and had everyone inside line up to take a breathalyzer. Many of us left with underage drinking tickets and a good lecture from our parents.

Liam and I both made it home later that night. Still, he somehow had a positive attitude. He said to me as we walked by one another, "Hell of a party, am I right?"

I looked back and said, "Something like that."

He responded, "We did get you back out there, at least. Keep your head up. There's more out there for you; post your ex."

Liam died from an overdose when we were twenty-four years old. He had been fighting drugs for many years. He will always be someone who I look back on as kind. He was someone who knew how to lighten up a room or almost any situation with his quick wit and humor. He died much too young and made me take a good look at myself to make sure I was on a good track to achieving my dreams and goals in life.

The blue footprint of my tattoo represents Liam. He is the fourth footprint of my Moose.

\sim

The lessons and memories I have associated with these four people who are no longer with us are great. I try to enjoy life today and every day with my memories strong and my heart full. I feel lucky to have known them and trust that they will be a part of me forever.

Each footprint of my Moose tattoo represents a part of my past that changed me/shaped me into who I am today. Instead of burying the pain and grief, I choose to remember the good times with the bad

and remember the things I learned. It keeps me humble and reminds me to learn from my past while continuing towards becoming my future self intentionally.

CHAPTER TEN
THE SNOWFLAKE

As a baby, I received a polar bear stuffed animal named Snowflake. He went everywhere with me. Outside or inside, he was in my arms. He slept with me and kept the monsters away. He was there when I cried and when I laughed. Snowflake was the very best security blanket a little girl could wish for, and he was cuddly.

~

Fear starts when you are young; you fear being separated from your parents, what is hiding in the dark, strangers, and more. This emotion can overcome us in anticipation of danger or threat, whether imagined or real. Many fears transform as we age into understanding when to be afraid versus feeling safe. Even as adults, we don't always get this balance right, but for the most part—fear tends to be different as we become adults. It becomes more focused on things like the fear of not being able to pay my bills, the fear of running out of gas because I have pushed the limits of the car too far, or the fear that my health check-up is not going to go well.

Snowflake taught me a lot about fear and what it takes to overcome it. But as I got older, my parents wanted me to let go of the need to bring Snowflake everywhere. It began with Snowflake having to stay inside to wait for me upon my return if I was playing in the dirt. Then the rule was that Snowflake had to remain in his place in bed when I got up for the day, waiting for me to return when it was time for bed. Eventually, Snowflake had to sleep in his own bed (next to mine).

The most memorable moment I associated with Snowflake was when I was around ten years old, and I wanted to have a spontaneous sleepover with my friend, but I didn't have Snowflake. My mom was already there to pick me up, and I was negotiating with her that I wanted to stay the night. I wanted to stay so badly, but I also felt like I needed Snowflake, as we were still in the phase where I slept with him in the bed, but didn't take him with me when I woke. She told me I could stay, but Snowflake would not be joining the sleepover. To be fair, not only was she trying to wean me of the need to have him with me, but it would have taken her more than forty minutes to get him and bring him back. She said, "Sami, you can stay for a sleepover without Snowflake, or you can come home with me now and have Snowflake with you tonight."

I sat and pondered the choice, upset and secretly hoping that she would see me upset and change her mind. I sat, and I thought about the protection Snowflake gave me. My friend went inside, got one of her stuffed animals that she loved, and told me I could borrow him for the night. I held her stuffed animal and said thank you—and thought, but you don't understand, this is not Snowflake.

I had associated so much safety and protection with Snowflake, I was not sure that I would be able to sleep without him. Everyone around me knew I was struggling with this, but they didn't really understand what Snowflake and I went through in the middle of the night, in my dreams, awake or asleep. Only Snowflake and I knew.

Finally, I decided that Snowflake would want me to stay and that he was always with me. I held my friend's stuffed animal tightly and thought of Snowflake as I closed my eyes. I woke up the following day, surprised that I had survived the night without him, and that I had

slept and was okay. When my mom picked me up, we went straight home to check in with Snowflake and tell him all about the sleepover. Of course, he was happy for me, and my mom thought he supported me having more sleepovers without him if I wanted to, which I was more comfortable doing from then on.

~

Snowflake also taught me about love—the unconditional kind. Snowflake saw me during all moments of life for the first several years I was on this planet, and he was never judgmental or not listening to me. He stuck with me during the good times and the bad. He loved me, and I loved him forever.

Snowflake would listen better than anyone and always take my side. He would sit with me when I felt terrible and go with me to say I'm sorry to whoever I needed to, but only when I was ready to apologize.

The big secret is that Snowflake helped me to learn how to love myself. All the energy I put into Snowflake's love was targeted at me. He was my mirror, he was my coach, and he was the wisest part of me. He helped me give myself permission to take space to calm down instead of saying things I did not mean. He helped me own my wrong doings as well as celebrate the things I was proud of. He helped me take time to self-reflect every day for many years before I closed my eyes and slept. For those lessons and growth, I will forever be grateful for my relationship with Snowflake.

~

I got a snowflake tattoo to represent the lessons I learned from my polar bear, Snowflake. This tattoo is on my sternum (my core) and reminds me not to fear loving myself daily and owning what I need or want proudly. It also reminds me of my moral compass and who I am if I ever feel lost.

It is a snowflake because I love that no snowflake is alike—they are all unique, just like humans. Snowflake, the polar bear, reminded me

that I was special every day, and the symbol of a snowflake fit his spirit (and mine) well.

To Live Would
be an awfully
BIG ADVENTURE

CHAPTER ELEVEN
THE QUOTE

When I was a kid, one of the movies I played on repeat was Peter Pan. I loved that a group of kids lived in nature and did not have to answer to any adults, staying young forever. I wanted to be Peter Pan himself. He was brave, kind, and seemed to be a good leader for the other kids.

Once I was older, I saw Hook, also about Peter Pan, but with a twist! I loved it—I thought it was funnier, more complex, and fabulous. I also watched this one on repeat, obsessed with Robin Williams playing Peter Pan as a grown-up, being reminded of his childhood, and becoming a better person because of it.

～

Living in the moment for today has been ingrained in me forever. Living knowing you are dying one day and how that day could be sooner than you think. Without fear, but with an awareness of what is happening around you. I said this often to those who would listen; I even made a car decal for myself in my graphic design course in high school that said, "Live for today." I was so cool.

There are other versions of this quote, like "Be where your feet are," which I also often reference. It is so easy to get wrapped up in the past or the future that we forget to live in the present. On the other hand, we can get so wrapped up in the present that we forget to plan for the future. This balance has always been an interesting one for me, especially as my dreams have gotten bigger and the need to plan, save, and prepare has grown with them.

One of the ways that I have used to focus on the present is through cardio. I started playing sports at a young age. I played soccer, basketball, swimming, gymnastics, dance, volleyball, golf, and more. My parents felt strongly about me picking a sport and sticking with it as I got older—they were both incredibly athletic when I was young, having six packs and exercising daily. I chose soccer as my primary sport and quickly realized I had a love-hate relationship with running—I enjoyed it when the game was in session but did not love to run around the field just to stay in shape. Long-distance running was never my thing, but I did become obsessed with soccer (walk, jog, sprint, stop, repeat).

It was an outlet for me—I felt powerful and present in an unmatched way while playing. It did not matter to me what was happening outside of the game, as my legs in a sprint were unstoppable. While sprinting, I could only focus on my breath and the ball. Breathing in and out as I took strides to my setup before kicking the ball. It was like I was underwater, everything else not being loud or clear enough to get through to me in those moments of a full sprint and afterward, recovering to myself and my legs. Feeling my thighs scream but loving it each time (leg day will probably always be my favorite gym day).

Being on the field was like therapy, and it was what kept me sane as my world shifted and changed around me. It also felt good to be strong. To be fast. To be able to jump up and do anything with my body without fear.

I dreamt of the adventures I could have, the battles I could win and the mountains I could climb. Living in the moment for today meant even more with what I could do and see, pushing my body's limits. Everything felt possible and within reach.

~

My childhood was during the pre-technology boom—what this meant for my family was that we mostly played outside. Our parents allotted us a small amount of screen time (a TV and eventually a computer) each week, but we had to entertain ourselves for the most part.

Luckily, I loved the outdoors. Since we grew up on the side of a mountain, there were trees, flowers, and animals, and our driveway had a basketball hoop. It was heaven, even when it was snowing. I was always looking for something to build and make mine, like a tree fort or a shelter under the deck. Depending on the fort—different friends would come to play and help me build or organize it, creating special places for each close friend.

Fort building was more than a phase and didn't just happen at my house but also at others. I had a friend with an epic tree in their yard that we had permission to build a platform on and make a crazy cool fort. We had to figure out how to get the wood up to where we were building and get things to stay where we wanted them. We thought we were geniuses when we figured out how to set up a pulley system.

Once we built a platform, our parents checked our work to ensure it was safe enough for us to play on—once approved, we started planning our next project. What fun things did we want to add to our fort that did not hurt the tree more but added to the experience? We devised different routes to get up and down the tree—ropes to climb, ladders, and which branch was safe to hop off. It was like an amusement park as far as we were concerned.

Of all the adventures I have had, some of my wildest ones were built right in the backyard with the imaginations of young humans. Many things happen throughout life as we grow up that push us further from the feelings of our childhood adventures, and I think it is a shame. These adventures can help keep us creative and young and remind us to laugh and have fun.

I had all kinds of childhood adventures worth remembering—archery, fort building, river tripping, hiking, biking, rollerblading, rock hunting, train track finding, bug seeking, snowball fighting, capture

the flag and more. Most of all, I spent a lot of time thinking about how magnificent the world was and how much there was to explore and be curious about.

To this day, I try to tap into that same adventurous spirit and get curious about the world around me. It looks different now (less fort building) but bigger dreams and goals. Bigger curiosities and studies.

~

During an undergraduate summer, I took a solo trip down to Guatemala. For five weeks, I was an intern during the week at various clinics and hospitals across Guatemala City. I was part of a group that was mostly people from the United States who were around my age (in college). On the weekends, I took trips to black sand beaches and the temples of Tikal.

While the overall experience was incredible, there were many reminders that the world was unfair. People's lives were at risk every day in different ways, depending on the place. At the time, Guatemalans faced gang rivalries, a corrupt government, severe poverty, and terrible air pollution, among other issues.

There was a lot of gun violence between gangs and dangers while moving around the city. We were staying in a hostel-like location owned and operated by the company we were interning/volunteering for while there. It was a safe place where there was food available to us, etc.

Our group was assigned a trusted cab driver we were to use when we wanted to go out into the city. The cab driver barely spoke English, but it became clear quickly after meeting him that he was a good person and was there to keep us safe.

On the second ride I took with him, there was another intern in the back of the cab and me—we were stopped in traffic, and someone came up to the back window and tapped on it with a handgun.

Tap, tap, tap—"Give me everything you have on you. Now!"

We looked at him and then at each other and started collecting our things with fear in our eyes. Before we had everything together or

the window rolled down, our cab driver got out of the car wielding a machete. He was screaming in Spanish, waving the machete around, and the man with the gun ran off. He got back into the car and cursed under his breath. And it was over—just like that.

Another time the cab driver helped us get out of a sticky situation was when we wanted to go out to some bars one night in Zona Viva (the part of town with a good amount of nightlife). While there, we danced and drank tequila—having a good time. A man came up to me on the dance floor and grabbed my arm tightly; I tried to pull away, and he said something I did not understand in Spanish. I said no and pulled my arm away. He grabbed me more tightly and tried to pull me closer to him. Another intern saw the exchange and started yelling at the man in Spanish. They argued with one another, and even with my poor Spanish, I understood that the man wanted me to go home with him, and my peer was telling him no. There was more yelling, and I was able to pull my arm out of his grasp.

I went to turn in the other direction to leave when there were guns drawn from several people around the man trying to take me with him. We realized we were in more significant trouble and needed to leave the bar quickly with the rest of the group. The eight of us started walking rapidly down the street, trying not to draw too much attention to ourselves. The men with guns came out of the bar and started running after us.

As we decided we should also run, a man got thrown out of a bar—right into the pathway in front of us—the bouncers yelling at him and him yelling back. We awkwardly got around him just as police officers wielding sawed-off shotguns came from another direction. The officers and the bouncers were all yelling at the man on the ground, and the men chasing us were no longer running as they approached the scene with the police.

The man on the ground suddenly pulled a handgun and shot it into the air. We took off again as the police officers fired back at the man with their weapons, sending shrapnel everywhere. We got to the end

of the street, where our cab driver was waiting—ushering us inside to remove us from the scene. Three of the eight in our group had shrapnel in their legs and had to go to a hospital for care. Luckily, the shooting didn't severely hurt anyone, though some have long-term scars. Once again, the cab driver saved us.

My third incident with guns in Guatemala City was while I was working in a clinic. This clinic was small but part of a larger building with other services for the community. I was able to do simple things to help there, like take vitals and give certain shots.

One day, I was giving shots to people and had a needle sticking out of a man's butt when I heard a firecracker go off. Everyone in the room dropped to the ground (including the man I was treating). He had rolled off the table, the needle still somehow in his butt, and I was being pulled to the ground by the staff.

Confused, I said, "Firecrackers?"

And someone said back, "No ... machine gun."

I stared back, startled that I could not tell the difference between the two sounds. Reflecting on the fact that everyone else in the room could. We stayed down on the ground like that for several minutes after the gunshots had stopped. One of the staff stood and looked out the window and told us we were safe to get up.

We all rose from the ground and went to the window to see if we could see anything. Unsure exactly where the gunfire had taken place but knowing it had been very close, if not on the clinic's front steps. We saw a body through the window, surrounded by others who had either come out of the clinic to check on the person or who had been nearby on the street. The body was lifeless, and the people were simply standing there, some in tears, and others quietly talking to one another.

I asked one of the staff standing next to me what had happened and what we were going to do next.

They said, "It was likely a targeted kill. Our job is simply to continue serving the community the way we have been all day. The authorities will come and get the body soon."

I stood trying to keep my composure. Someone was shot and killed right in front of the clinic—and there was nothing for us to do but keep on treating the patients we had. How can life end that quickly, yet go on like nothing had happened?

My fourth and last experience with a gun while in Guatemala was during a hospital emergency department shift. I shadowed a doctor there and would help wherever and whenever possible.

The emergency department was one big room (like a high school gym) with gurneys lining the walls.

An ambulance dropped off a man with gunshot wounds, one through his cheek, one through his shoulder, and one through his stomach. He was yelling out in pain. I grabbed gauze and started putting pressure on two of the wounds, looking up for further instructions.

The doctor was talking with the ambulance team and seemed frustrated. He then turned to me and told me to stop caring for the patient.

I said, "Why? We can help him."

One of the ambulance team members responded, "He is going to die either way."

The doctor looked at me and said, "Step away from him, Sami; you need to move out of the way and help someone we can help."

I did not understand, but did as I was told.

About fifteen seconds later, a man with a machine gun came in, shot the man several times until he was dead, then walked out the front door. I stood in shock. The whole room was silent and unmoving for about thirty more seconds. Then people cried silently and started cleaning up the mess.

Once I could speak again, I asked what had just happened.

Why hadn't anyone stopped that person from killing that man? There was security at the emergency room entrance; many people could have intervened but didn't. Why?

The doctor told me, "That was a targeted kill by one of the larger

gangs here. If anyone had stood in the way, they would have died today, too."

I continued to cry as I let that sink in and removed my gloves that were still covered in the dead man's blood. Reflecting on how this kind of thing could be a part of the world?

How could this be acceptable? How can we all just continue our day? Was his life not as important as others?

We treated many patients the rest of the day, but the mood never lifted in the clinic. After my shift, I returned to the hostel and lay in bed for many hours before finally closing my eyes.

$$\sim$$

Peter Pan said, "To die would be an awfully big adventure."

I like this line—it represents Peter's fearlessness and adventurousness. After all the death I have seen in different forms and places, I am also not afraid of death the way some are.

Death does not define my movements through life. I have seen death in many different forms and believe that death (and whatever happens to us afterward) is not something to be afraid of … but instead, it is something to respect. Like the powerfulness of the ocean, or the fear of a mother whose baby is in danger.

For a while, I thought that learning to live was more challenging than being with or in the presence of death. Because of this, I instead got a quote from the movie Hook tattooed on my thigh, "To live would be an awfully big adventure." Each word in my tattoo is in a different font and style because—adventure, why choose one?

CHAPTER TWELVE
THE POLAR BEAR

Polar bears are intelligent creatures that are just doing what they have to do to survive.

Polar bears have always fascinated me for various reasons. We know them for their strength, power, beauty, and patience, all characteristics that I find so endearing.

• They have incredible strength—they can lift icebergs and run up to twenty-five miles per hour. They are heavy animals, making a hit with a paw very dangerous.

• They are full of power—being the top of the food chain in the arctic circle.

• They are also highly graceful—beautiful creatures whose primary enemy is climate change.

• The patience that polar bears have outweighs almost any other fact about them for me. They are not only excellent fishers but are also known for lying down on their back in the snow and covering their noses and paws with snow to camouflage themselves. Then, they wait

for their prey; they sit up quickly and attack when something is nearby.

It is bonkers to me how terrifying that experience would be to be on the other side, as well as the patience of lying still for however long it takes for something to come by.

~

I thought I was in good shape in college—active and still intramurally playing soccer. I went to the gym five days a week and was feeling strong. I signed myself up for a walk for breast cancer—committing myself to raise $1,800 and walking thirty-nine miles in two days.

Breast cancer plagues many people every year, especially women. According to the National Breast Cancer Foundation, Inc, on average, doctors in the United States diagnose a woman with breast cancer every two minutes. So, I wanted to do something to raise money for the fight against this horrible disease.

I convinced a good friend to walk with me, and we set out to raise money. We asked everyone we knew to put whatever they could toward the cause. It was emotional for me, as each donation felt more like support than people knew. I felt like my mom's story and her early death meant something to even strangers, and I reached my goal and earned my place in the walk.

The walk was in Washington, D.C.—we camped overnight and stayed with other walkers in a large grassy area with catered food, bathrooms, and medical tents. When we arrived, there was a large crowd, most people wearing pink in support of the cause. Everyone was dressed up and ready to walk. All there for different reasons, in support of themselves, their friends or family, or simply because breast cancer takes so many lives every year. Why not do something to fight it?

Before the walk started, there was an opening ceremony. The ceremony was a time for people to speak to the cause and thank the group of walkers for raising the money to enter the walk. It was full of motivational words as we were all about to do a challenging thing ... walk thirty-nine miles. I stood there listening to the opening speeches, crying in silence, wishing for a better world, and wishing I did not

have to live with the fear of also getting breast cancer at a young age. I thought of my mom and all the pain and suffering her body went through physically because of this disease and how different my life would be today if I still could call her.

The speeches ended, and they cut the ribbon to begin the walk. My friend and I, and the thousands of others there to participate in the event as walkers, started putting one foot in front of the other, talking when we felt like it, and walking in silence as things got harder. Things for me got really hard between miles eighteen and twenty. It became only our mental drive that pushed us forward.

Twenty-six miles on the first day—my blisters formed halfway in, as I was not as prepared as I thought. My gym routine and soccer playing did not set my feet up for success for such a long trek. My friend and I kept our heads up and kept on walking, luckily knowing each other well enough to not be our best selves in all moments of our walk together without judgment. Medics provided blister care at each rest stop. Our bodies were exhausted and beyond tired when we reached camp, but we had done it! We ate early—got more blister care—and slept hard, not even minding that we were in a tent. Getting up to go to the bathroom during the night was hard. The bathroom was kind of far away, and every step hurt. It felt like a punishment to have to walk even ten steps.

We woke up the following day and ate something. We received more blister care and stood at the starting line with everyone else, questioning how we would be able to walk another thirteen miles. We started walking with the group, and luckily, our minds were strong as our bodies warmed up slowly, making it slightly easier to take each next step. We decided we would walk at our own pace and get there when we got there like a turtle instead of a hare.

I remember thinking it was a miracle when we crossed the finish line later that day. I could not believe how much my body hurt; parts of my body I had never felt before were aching. My feet were a wreck, covered in blisters. The size of my blisters was inconceivable to me, one of them being the entire front pad of my foot wrapping around to the tops of my toes. But we had done it—we had walked through the pain

and aching body parts. We had survived, knowing that what we had achieved by walking those thirty-nine miles didn't come close to what the cancer treatments and pain were like for those who were not there to walk with us because cancer had taken their lives.

I have done the same walk several times, each being a physical challenge different from the last. But each time was a powerful experience, and I am grateful for my body being able to walk at all. I am still cancer-free and moving, grateful to be able to donate to the cause, and hopeful that progress will be made so that my daughter will not have to fear this type of cancer.

~

I was one of my brother's emergency contacts. After my mom died, I became the emergency contact that was the easiest to reach. At thirteen years old, I was one of the first kids in my grade with a cell phone, and the school allowed me to answer it every time it rang. The teachers in my school knew that if my phone rang, it was likely because of an emergency at my brother's school. I would simply lift my red Razer phone in the air, and they would dismiss me to the hallway.

I would answer like a typical teen, "Hello," and then answer any questions they had about Michael's diabetes care. Things like "he doesn't seem quite like himself—we tested his blood sugar a half hour ago, and it was fine ... what should I do?" Or "Michael is feeling like his blood sugar is low—how many glucose tablets are okay for me to give him?" I would always answer their calls and questions and sigh—life isn't fair. Michael should be allowed just to be a kid and not have to worry about his blood sugar or needing to give himself insulin every time he eats.

My brother was always a trooper—he felt more frustrated by his additional care than bad for himself. He patiently explained things to adults and put up with my dad and me checking on him often. Having no working pancreas made it so that there was no other choice than for him to take care of himself with the help of those around him.

I reflect on this part of our lives and notice the dynamic power

shifts. It was odd to both take orders from adults and explain things to them, needing them to listen. I felt frustrated when the person listening wasn't paying attention in the way I needed them to since this was serious. I needed them to take the information in—because things could go south fast, and my brother's life was my highest priority. I learned to slow down and wait until they were listening, and I could tell the information was being received. This took more time for some and less time for others. I believe most would begin listening because my eye contact and patience I was presenting surprised them.

I grew to see power as a dynamic that was more about being in a position of authority—whether that be a job title, a delegated task assigned by someone with a title, the most knowledgeable person in the room, or the strongest person in the room. I saw many examples of leaders growing up that I perceived to be frightened by their power - not sure of themselves the way they maybe should have been. On the other hand, I saw people yell at those around them, making people fear them but not making a shift in them the way I thought they wanted to.

All versions of power were examples to grow from. I struggled at a young age to understand what I was meant to do when I grew up. Was I meant to care about the "silly" steps in life ... like learning to take the SAT or the ACT? Why were those things necessary when there were other, more significant things to worry about, like whether the substitute teacher would call me at the first sign of Michaels's blood sugar crashing instead of waiting until things were much worse?

Today, I see power as something similar but more complex. Each individual defines the most crucial part of their own power. Others will take advantage if you do not feel powerful in a situation. If you do not articulate your knowledge to others well enough, your good ideas may not come to fruition. Power is knowledge, but you also need it in spirit before you may have whatever power the situation calls for at that moment. We almost triage power from situation to situation. It is like a dance-off sometimes and can bring out the ugliest pieces of people. It is both a gift and a curse. When wielded well, though—power is an unstoppable force within each of us.

~

As a kid, I spent a lot of time thinking about what beauty meant. I would think about all the things that I thought were beautiful—sunsets, the mountains, the dogs running happily down the side of the hill. I never witnessed anyone in my family take a long time to get ready or put on a lot of makeup. I didn't spend hours learning how to put makeup on or do my hair in a bunch of different ways. I spent time learning how to build a fire or playing sports until it became too dark to see. Beauty, to me, was about people's insides and the natural world.

I learned to always be aware of my impact on nature, to leave a smaller, lighter imprint on the world—cleaning up trash on the side of the road while we walked, never leaving a space worse off than how we found it. Anytime I would complain about our trash pickup walks—my parents would remind me that even though we didn't put the trash there, it is our earth, and keeping it clean is what is right for the planet and us.

We sang songs while we walked and cleaned the side of the road—my brother and I searching for the hard-to-get trash—competing for "the best grab." We talked about how beautiful things were—even the things that may go unnoticed. When we walked by people, we would say hello happily, and when we walked away, we would say something we liked about them. I didn't know it then, but these walks had a significant impact on what I still find to be beautiful.

A man who was kind of scary looking lived down the street, with an oxygen tank and a big scraggly beard. His house never had the light on and looked like a creepy house in a storybook. He would often be sitting out on his porch or taking a walk himself. My mom was never shy to start a conversation with him, and Michael and I learned to lean in as well, since she didn't seem to carry any judgment or worry.

Once we started chatting with him, I quickly realized that I loved our conversations—he was always so excited to say hello to us and hear all about our day. He had to cover a hole in his throat with his hand to talk to us, and his voice sounded like one of a villain. But his heart was huge, and he loved to laugh.

As soon as I let myself see his insides (who he was as a person), I thought he was beautiful and was frustrated at the idea that others misunderstood his version of beauty since his hair wasn't often brushed, his house was not inviting, and when he spoke, he sounded scary. His insides were beautiful, and not everyone gave him a chance to show them who he truly was because of how he appeared.

I looked forward to running into him on our walks or in the grocery store. Michael and I would run up and hug him and ask him about his day, making sure others saw us as we made a loud approach. We would also tell the neighborhood kids how great he was and how much he loved to laugh, taking it upon ourselves to correct people's judgments.

As I've grown up, I am still disappointed at how quickly the world moves around me. People are not caring what their impact is on our planet or others. Walking by homeless people like they are gross instead of greeting them and wishing them a good day. I am guilty of this more often than I would like to admit, but I often remind myself about our "beauty walks" and try to do better each day.

We quickly assume things about others when we first see or meet them. It is so easy to jump to assumptions that I would even call it lazy. Society trains us to make flash judgments of each other and move with "business brains;" and forget that we are communicating with other humans. This is heartbreaking—I saw it as a kid and see it even more today. I hope to impact this by reminding people that there is another human on the other side of each conversation—even the ones you have with yourself, be kind to each other. You never know what challenges or hardships someone else is facing or what caused them.

~

When I reflect on patience, I almost immediately jump to "patience is a virtue." It's funny to me because I think I have a lot of patience for many things but am also short-wicked with certain things. I am not sure what the right balance of patience is, but I know that I lose patience quickly when stuck in traffic, waiting in line, or when I can see operational fail points that nobody is doing anything about. Efficiency is a big deal

to me when I'm trying to move from point to point. This one I can attribute to my dad. He is one of the least patient people you'll meet; the good news is that he has become more patient as he's gotten older. This gives me hope that I can do the same.

One of the chores assigned to me over a weekend when I was a young teen was to move a massive pile of cut-down tree branches to the bottom of our long (about ⅓ of a football field) and steep driveway. Someone from the city had come and cut down a bunch of tree branches that were not up to the Fire Code surrounding our house. Living up a canyon in a cabin—this was a lot of tree branches. My job was simple, but it would take a lot of work.

There was going to be a dumpster in which the tree branches were going to be placed at the beginning of the week, and my dad wanted the branches to be as close to the dumpster drop location as possible. So, my two closest friends at the time and I started dragging the branches one by one down the driveway. We knew that until this chore was done, we couldn't do anything we wanted to do. So, my friends committed to helping me finish the job so we could hang out.

It took us hours—and much patience. We practiced patience with each other as we helped lift a branch out of the pile (they were heavy, and we were not always communicating well). We also practiced patience with our bodies as we slowed down after a while—as we got tired—directly in conflict with us getting the task done as quickly as possible. We finally got all the branches to the bottom of the driveway and had just sat at the top of it smiling when my dad came outside and yelled from above, "never-mind, the dumpster will be at the top of the driveway!" We looked up at him and said, "But we already moved the whole pile," and he said, "Well, move it back up!" We stared at each other before getting up and walking back down to the bottom of the driveway to assess the best way to move the pile again.

I couldn't believe how angry I was at that moment, feeling physically exhausted and not getting the time with my friends that I wanted to have that day. He went back inside, and I practiced patience once again—he didn't know the dumpster was going to be at the top

of the driveway—he didn't mean to put us in this situation. But damn, it sucked!

We went to the bottom of the driveway and started moving the branches back up to the top. At first, we were grumpy, but after a trip or two, we started laughing about how ridiculous the situation was. We found the light in the situation and made jokes while we worked the rest of the day, at peace with the fact that this would be how we spent the day together. There would not be time to do anything else before their parents picked them up before dinner.

At last, we moved the branches back to the top of the driveway and sat down as one of my friend's parents pulled up to pick her up. We hugged and giggled as she got into the car to go home. The day had not gone as planned for us, but with patience, we made the most of it. We knew that we were lucky to have such a good friendship and would have more time to hang out.

To this day, I work on my patience, not always sure how to be patient with myself and others in the more frustrating moments. I continue to hone my leadership skills that require patience, like deep breathing exercises, letting stuff go quickly, and wielding the tools I have in my toolbox intentionally in response instead of reaction. Reminding myself to laugh things off and make the most of any situation like we did that day, dragging branches up and down the driveway. There is almost no value that I have gotten from this life holding on to a lack of patience, and it has even caused me to not be in the moment with those around me.

~

I got a polar bear tattoo reminding me of my strength, power, beauty, and patience. It is an outline of a polar bear, with the inside being filled with the natural habitat of a polar bear. It is on my thigh, walking with me through life. It is an access point for me to recenter myself and my poise.

CHAPTER THIRTEEN
THE LOTUS FLOWER

At night a lotus flower submerges itself back in the murky water and somehow, the next day, reopens, laying just on top of the water, never appearing like it had been in the muddy water at all. No matter what, it looks clean and pure. They are unique flowers with great metaphors associated with strength, resilience, and rebirth.

Friends and family are, in many cases, one and the same for me. I have been lucky enough to have deep friendships in my life that have created deep bonds. Oftentimes, creating these bonds through our shared stories that represent our growth through or despite the muck that life has brought us.

~

I moved to Austin after I graduated from nursing school. I was trying to figure out what to do with my life and was in a weird phase (which I now lovingly call my quarter-life crisis) while also being in a new place and not knowing anyone in town. I got a dog within a few days of moving into an apartment complex that seemed to have it all: pools, dog parks,

gated communities, a bar, several gyms, and more. I adopted Moose at around six months old, and he seemed scared from his earlier life in many unseen ways. We dealt with pretty severe separation anxiety and general nervousness.

It was hard, to say the least. My life decisions and being a new dog mom who moved away from all support overwhelmed me. So, I picked up some beer and went to the main pool. Somebody told me before moving in that it was the place to be on the weekends and in the late afternoon, with DJs, pool volleyball, grilling, and more. I set up shop and sipped on my beer while taking in everything and everyone around me. It really was a party.

Pretty quickly, a group nearby invited me to play water pong (floating beer pong). I accepted and crushed the competition. While playing, I introduced myself to everyone in the group and got to know a few people. It enamored me how "I have my shit together and know how to party" everyone appeared. Meaning they all had good or better-than-average jobs, tech companies, bar managers, and more, but were also fit and partiers.

One woman, Tracy, seemed to be the connection point to all. She announced that she and her boyfriend would be hosting an after-pool barbecue at her apartment and then pulled me aside and asked me if I wanted to join. I told her about my dog and that I had to go home— she listened, looked me in the eyes, and said, "Bring him!"

I couldn't believe it—it seemed I had begun to make friends, and I would be able to care for Moose simultaneously. It was a big moment for me. It was like there was light at the end of the very dark tunnel I had been wandering aimlessly in.

Tracy and I talked until very late that night and became close quickly. Neither of us was afraid to be vulnerable or real with the other. It felt like I had found a piece of home in my new home. She was fun to be around, the life of the party, and she knew how to get what she wanted from every situation in an impressive way.

～

Tracy and I continued to grow our friendship until we lost words to describe what it felt like—one day, we were at a happy hour with her coworkers, and someone asked who I was and who I knew; Tracy yelled from across the room, "that's my sister!" I thought—yup, that's how close we are at this point—let's go with that.

We had a blast tearing up the town for years. Tracy helped me figure out what I wanted to do with my career and helped me apply for job after job. She even got help from her family members to edit my resume, level up my cover letters, practice interviews, and more. She was there for me through breakups and the many moves I did (I moved around once a year, sometimes more often) and called me on my bullshit while supporting me with love.

Our favorite thing to do was sit on one of our patios (preferably in a hammock) and talk about everything while looking into the night sky. It felt like someone was looking out for me more significantly during this time than most relationships, seriously more like a sister would.

Our relationship started to get a bit harder when I moved away to take a job in Seattle. When I would visit, it always felt like a whirlwind and wasn't as recharging as I hoped it would be. It was like we were still neighbors, but we weren't. Quality time was getting harder to find with more pressure over time and how complicated our lives became.

≈

Tracy took a solo trip to Seattle after her wedding, where we got some much-needed one-on-one time and had a blast. We decided during the trip to get a lotus flower tattoo together on our ankles. The lotus flower represents resilience, strength, and rebirth. The flower resonated with both of us, and it felt good to get together. We had both been through so much throughout our upbringings and even in adulthood that it felt like a good shared experience to have with one another and a symbol that we could both resonate with easily.

≈

Years later, Tracy and I had a big falling out. It was challenging for

me to let go of what had been and take a good look at what was. The relationship felt significantly harder—like it was not whole anymore and I felt incredibly misunderstood. It was almost like it was frozen in time in her mind and she didn't see the growth that had happened within me. It was time to let it go, which felt like a death in the family had taken place, but relationships change over time. As we age, grow, and hold values differently. Our life priorities had shifted, and ours did not shift in the same direction, surprising us both.

CHAPTER FOURTEEN
THE WINE GLASS

Some dreams feel crazy and impossible until you truly believe in yourself. Russell and I love to travel. Early in our relationship, when I was twenty-seven years old, one of our big trips was to Spain, Morocco, and Portugal. It was a long trip, and we loved it. Spain and Morocco were on our list for this trip, partly because of the Master of Business Administration (MBA) program I was completing. There were two in-person immersion requirements, and a trip to Spain and Morocco was one of the options. Russell convinced me we should also hit Portugal for a few days to kick the trip off, as it was somewhere we both wanted to see and was so close by geographically.

Starting the trip in Portugal, we flew to Lisbon and took a train to Porto. Portugal has the most beautiful vibes, feeling very much like old Europe because of the architecture and cobblestoned streets while also being on the water and very affordable to tourists. We quickly decided we would be back, as a few days was not enough time to take everything in.

In Porto, we visited a winery that offered a tour of how they made port wine. While tasting some super yummy wines and taking

everything in—I noticed a woman across the room with a small wine glass tattoo on her arm. I commented to Russell and told him I loved it, yet doubted that I would ever get a tattoo that was visible to others when I was wearing a short-sleeved shirt. At the time, almost anything I wore except for on my feet (also very easy to cover when I wanted to) would cover the only tattoos I had.

I dreamt about getting a wine glass tattoo on my forearm for months following our Porto trip. It stuck with me, and I couldn't shake it. It was the first tattoo I had seen on someone else that I wanted to copy, and I didn't know how to feel about it. So, I thought about why it meant so much to me. Why did it stand out in this way that I couldn't shake?

One of the things that has been a constant throughout my adult life is my love for wine. It started slowly, dabbling in things like cheap boxed wine paired with Disney movies and best friends. Eventually, my curiosity led me to work at a wine bar to learn more about wine, where it comes from, how it's grown, and the different flavor profiles. Next, I started taking trips to wine regions and finding wine bars and wineries worldwide to check out and learn from. It became a hobby for me, one that has stuck over the years.

As I experienced more wine, I only became more intrigued. I loved how wine brought people together, no matter where I was in the world. Sharing a bottle of wine at happy hour, sitting on a blanket for a picnic with a bottle of wine on ice, gifting someone a bottle of wine on birthdays or holidays, you name the situation, and I'm sure wine has been there before.

As I look at my life and what I truly care about, having a connection to myself and others is the highest on that list. I have always found that people in a bad mood rarely fill wineries, regardless of where they are. In fact, no matter who you pay attention to, who you're with, or even how into wine they are, wineries tend to be filled with people in awe. When you look around, you see people teaching others about wine, connecting with one another through stories, looking out at the scenery, and soaking in the beauty of nature and grape growing. There is something for everyone to enjoy.

One of my biggest dreams is to one day own a winery. I would be the CEO that is active in creating a space that is inclusive to all and has really good wine. I want people to experience a culinary experience with wine pairings. I want people to be able to rent small houses on the property like a home rental experience, with multiple locations that can host private parties, weddings, concerts, fundraising events, team-building retreats, and more. I want a place where people want to come together and live in the moment ... being in nature while spending quality time with one another.

My winery would have elements of each of my favorite wineries included in the property—romance, natural beauty, elegance, and family; all carefully curated to help people connect to one another and themselves. I want the space to help produce creativity and play to allow people to open up. It will be a haven and a host to many memorable events for people of all backgrounds to enjoy.

~

On one of my most pivotal winery visiting trips, when I was around twenty-four, I went to a family-owned and operated winery in Napa, CA. It sold one of my favorite wines that we also sold at the wine bar where I was working at the time. The wine had a beautiful story about persistence being the key ingredient for many things in life, including the wine that was made.

I was there with several others but was in my own little world during the tasting. The winery staff caught on to how much I loved that bottle and allowed me to taste older vintages of it to see how it aged. They even let me purchase a library wine at the wholesale cost since I was in the industry! I couldn't believe it; the whole experience was just amazing. I learned so much, connected with the staff, and soaked in the beautiful weather on the cute little family farm. There was even a winery dog on the property that made things feel especially like home.

I still am in touch with that winery, and it is one of the many wineries on my list of favorites that I plan to pull concepts from for my

winery one day. I hold persistence as part of my core values, as I know
that it will take a lot of it to reach this dream of mine.

∽

I eventually did get a wine glass tattoo on my forearm; it is simply an
outline of a glass. It represents a reminder of my winery dreams as well
as the persistence that it will take to reach them. Plus, it looks "cool" as
I sip from an actual wine glass, taking in a brilliantly made wine, getting
curious with the staff about all the things they know about the wine,
how it was made, and by whom.

People often ask me, "Oh, why isn't your glass filled?"

I smile and say, "I will fill it once I reach my dream of owning a
winery."

I plan to fill my glass with a deep burgundy color representing a big
red wine swirling up and maybe even out of the glass—and those who
notice the change will know I have reached my winery dreams.

CHAPTER FIFTEEN
THE MOUNTAIN

One thing that my mom made sure she did before she died was to have a few conversations with my dad about where she wanted us to spread her ashes. Being cremated was an easy decision for her, as she wanted to be set free in the wind. She and my dad thought long and hard about this and decided on two places—the top of the backside of Mount Timpanogos and the main fork of The Salmon River.

These are both beautiful places that are difficult to get to, representing a piece of what my mom loved so much.

Distributing her ashes on the rapid of her choice meant that we as a family had to take a six-day river trip together, sans internet, cell phone service, toilets, or beds, with just the company of each other to get us through the journey. It took us several years to get to this distribution point, but we had an incredible time when we did.

The hike meant climbing over seven miles to the peak at 11,749 feet (the hike's elevation gain is 4,425 feet). It takes about nine hours and could only be done during certain times of the year, as the snowmelt on the backside was particularly slow and dangerous.

My dad's hips had taken a beating from all his exercises over the

years and were both considered shot (meaning joint pain and less mobility), making this type of hiking harder for him at the time. We looked into renting a helicopter to help us disseminate the ashes, as we all wanted to be there, but this turned out to be impossible. So, we started up the mountain one year in August and told ourselves that we would go as far as we could go together and then we would send those of us who could continue up to finish. We all got about 75 percent up the mountain (which was further than we thought we would get as a whole group) and were met with snow, making it impossible to continue. We opted to spread some of the ashes a little lower on the mountain together and promised we would return the following year.

When the following year arrived, Dad's hips were worse. He sent us to finish the distribution ourselves at the top. My brother Michael, his best friend/my second brother, Scott, and I made our way to the top of the mountain, having difficulty catching our breath as we approached the top. We were on top of the world, standing in a viewpoint box, put on top of the peak so that people could catch their breath safely. It was a 360-degree view and was just glorious. You could see snow-capped mountains, fields of wildflowers, mountain goats and deer, the city in the distance, and more.

We released mom's ashes into the wind and watched them float away. We all cried and laughed as we talked about her. We reflected on how she impacted each of us and how ridiculously fit she was (as she used to run this hike that felt impossible to accomplish for us).

~

Maybe surprising to us at the time, and now clear as I write this—one of my mom's big goals was to provide opportunities for us to connect. Knowing that both locations for spreading her ashes would require some solid quality time and some working together, she was brilliant in planning it that way. We all got quality time, enjoyed each other's company (most of the time), and could grieve and process together beautifully. It was another gift she gave us and a good reminder even now when too much time passes between us getting together.

~

The story of the mountain is something like Romeo and Juliet.

A Native American leader's daughter, Princess Utahna, was to be sacrificed to the Timpanogos Mountain god. She was to climb to the top of the mountain and jump off in sacrifice. The warrior Red Eagle followed her to the top of the mountain and asked her not to jump. The two of them lived in the caves on the mountain for several years before they both died (Princess Utahna jumped to her death, and a bear attacked Red Eagle).

There is a "great heart" within the caves at the top of the mountain (on the front side) today that is said to be their two hearts combined. It's said that the mountain's outline, which looks like a woman lying down, is Princess Utahna.

I think the legend added some significance to my mom's choice of where we were to spread her ashes. Though she died way too early at forty-seven years old, she was able to live a life she loved and fight through a long battle with cancer for my brother and me to have her in our lives as long as possible. I think she also had a great love story with my father—who misses her greatly to this day.

~

Because of my mom's early diagnosis of breast cancer at thirty-one years old and her age when she died, I have a team of clinicians focused on cancer screening for me. I am considered one of the lucky ones as I don't have the BRCA1 or BRCA2 genes or any other gene that scientists think may be associated with cancer today. However, because of my family history, I am still considered at high risk for breast cancer (almost quadruple the risk of others).

So, every year, I do a whole preventative care cycle: In January, I get a breast MRI, and in July, I get a mammogram. I believe going through preventive care is the right thing for my health, but it sucks to have to do it as often as I do.

Getting a breast MRI is like putting yourself into a torture device. You lay on a thin wooden beam that goes down your sternum with

your breasts hanging through two holes. Your breasts get pulled and adjusted, making sure as much breast tissue as possible is through the holes, ready to be scanned. Then, in case you aren't already physically uncomfortable, you're going to be made even more uncomfortable; you have to raise your arms above your head so that you evenly distribute your weight on the beam. You lay there for thirty to forty-five minutes in that position. You slowly lose feeling in your arms and settle into having some bruising from the bar on your sternum.

It is difficult to get up after because you can't feel your arms, and the blood flow returning makes your shoulders and arms tingle. It doesn't permanently hurt you, but it does take a while for you to feel like you can move again normally. Putting your shirt on to leave feels like a challenge round at a game show. Breathing hurts just a bit more because of how you were laying—also short term, but there's nothing that compares to that dressing room post-Breast MRI. This is being said by someone who enters this screening healthily, not having just gone through chemotherapy or radiation. I cannot even fathom those people's experiences.

The lasting impact, while not physical for me, is the mental game to follow. You go home and wait—sometimes days and sometimes over a week to get your results back. Did the MRI find something or not? If it did—which, if you are me, it often does because I have dense breast tissue and MRIs are sensitive—the next step is to do a biopsy.

During a biopsy, a huge needle gets inserted into your breast to take a small piece of the tissue the MRI machine highlighted. They then place a tiny flag in your breast so that the next time, they know they have already biopsied that mass. This process isn't exactly fun, but it isn't as bad as the MRI itself.

Now, after you receive the all-clear (for now), if you are on a high-risk plan, you have five months where you don't have to think about cancer (if that's possible). Then you go back in to get a mammogram and wait again for results, possibly leading to another biopsy.

Mammograms are also not exactly fun. Better than breast MRIs, but not a good experience. This time you're standing, approaching a machine covered in plexiglass and clamps. Your breast tissue gets pulled

onto a platform while your face gets pushed up against the plexiglass, getting you as close as possible so that they can scan all the breast tissue. Once your breast tissue is on the platform entirely, a clamp gets pressed down on it—flattening it as much as possible to perform the scan. Luckily, it doesn't take very long, but you leave a mammogram with sore breasts from all the squishing.

Like I said before about the MRI screening—the hard part is the mental game while waiting for results. I often feel like I am in remission even though I haven't had breast cancer to date myself.

Overall, it is an odd experience and feels like a dark cloud hanging over me often. I'm a fighter, though, and I know that if and when I do get a positive result, it will be early, and we will be able to treat it quickly, giving me a shot to live a long and overall healthy life and be around for my family's milestones.

Because of the story of the mountain and its significance to my mom, I got a mountain tattooed on the side of my foot. When I wear heels, it peeks out over the top of the side of the shoe. It is beautiful and seeing it on my foot reminds me to remain grounded even when the going gets tough. Through the hard times of waiting for test results or remembering there is beauty in the challenging moments, the mountain helps me stand tall and keep carrying on.

CHAPTER SIXTEEN
THE COMPASS

I was lucky enough to take the time one summer in college to go on a Europe trip alone, with $1,500 in my bank account. I got to go where I wanted to go when I wanted to go there. I had made a list ahead of time of hostels I could stay at for safety reasons. I had an entire month to travel, a tight budget, and an open heart. I had a tough year—not getting into the nursing program on the first try because my GPA was not high enough.

I did not get into my preferred program, so I had to study something as my backup plan and apply the following year again if I still wanted to get that degree. I chose psychology as my backup, as I had always loved my psychology classes. Soon after signing up for my coursework for the fall semester, I knew I needed to do some real soul-searching about my next steps. Did I want to be a nurse? Was psychology a good plan for me as plan b? Should psychology be plan a? What was I here to do with this life?

So, I took off to Europe—starting in one of my favorite cities, London. I knew London would be a brief stop for me simply because it was very expensive. I found the hostel on my approved list, booked it

for one night, dropped my bag, and looked outside, excited to follow my feet. To kick off my trip, I found a cheap pub crawl to join and enjoyed moving around the city with a group of young people like me for the night.

The following day, I packed my backpack and hopped on a short flight to Dublin. After spending a few days in Ireland, I made my way to Amsterdam, then to Berlin—from there, with a friend I met up with in Berlin—we went on to Riga and Tallinn. All these cities had so much to offer, and I likely wouldn't have made it up to Eastern Europe had my friend not been with me for that part of the trip.

It was magical. I French-kissed an Argentinian stranger in London. I ran around a castle counterclockwise in Ireland to get my virginity back (yes, I realize it is impossible to get your virginity back). I looked at the stars while lying in a skateboarding bowl with a Dutch friend I had met in Guatemala, talking about life (I crashed on his and his partner's couch while staying in Amsterdam). I cried while standing in the ruins of a concentration camp outside of Berlin. I fell in love with Riga—lost in the architecture's magic and the people's kindness. I felt like I was in a fairy tale in Tallinn, exploring a city that looked nothing like any other I had ever been to, and I made lifelong friends and memories.

But most importantly, I reminded myself of my purpose, what I really loved to do, and who I wanted to be. When I returned, I knew in my bones that my mission was to help people. I would apply for nursing school again, and no matter what happened, I would land in a field (nursing or psychology) that would allow me to help people.

Following my feet (being only in the present and going where I want to go and when) is not something I always find myself able to do—but what I know for sure is that the journey can be even better than the destination if you allow yourself to be present in each step.

∾

The internet says that fish are active during and right after a storm—making it easiest to catch them then. Knowing this, fishermen used to

stay in their location through storms (weathering the storm) because they were choosing between food and income or safety. This idea has always made me think about things more deeply; some storms are easier than others to weather.

Another saying or version of "weathering the storm" that is also well-known is "dancing in the rain." Both sayings speak to the fact that we aren't always in control and should make the most of our situation. I like to think that I can be a powerful storm myself.

As I was looking towards applying to nursing school in college, I decided it may be good for my application to get my EMT certification. The only way to do that in my state (Virginia at the time) was to volunteer at the fire department, and the path to do so was to become a firefighter (and through that, you could get your EMT certification). This excited me, so I signed up for an orientation course.

I got there and quickly realized that I was the only female and that a particular type of dude surrounded me. I was being hit on, and there were sex jokes within minutes of entering the building. It was a bit overwhelming to me as the day went on—I realized that the jokes were a part of the culture and that the training would be incredibly time-consuming and likely take away from my studies. So, I left the firehouse without signing up to be a part of the on-call schedule (which was the first step to becoming a part of the firehouse).

I went home and thought about what else I could do to enhance my application for nursing school, and on with my life, I went.

A few weeks later—my friends and I decided to throw a party while our Residential Advisor (RA) was out of town. We voted as a dorm on what kind of party to host and landed on a rave. We wanted a smoke machine and lots of glow sticks.

Being the type of person I am, I signed up to plan and organize most of it. The first thing I worried about was the smoke detectors and lights. The dorm hallway lights were always on—a safety issue—and we could not unplug the smoke detectors.

I thought about my fire department experience and knew I could quickly call the firehouse and get information on whether the smoke machine would set off the smoke detector. They advised me how to

avoid triggering the alarms and told me it should be fine. They even told me how to cover the lights without causing a fire. So, my friends and I went to work—setting up for the party.

We invited those we knew, who then invited those they knew. Within thirty minutes of our start time, we had darkness, glow sticks, smoke, and a whole lot of people. It was epic until the smoke detectors started screaming. Everyone ran outside and spread across campus on all sides of the building.

Within minutes, the fire department arrived. I walked straight toward the truck, and one of the guys jumped out and said, "Shit, Sami, I really didn't think it would go off."

I said calmly, "yea ..." and he said, "You better get outta here."

My friends and I walked away as the police arrived. The fire department and cops went through the dorm and cleared the building. They didn't pin anyone for the crime or the party. However, our whole floor received a good talking to the following week. Our RA entered each dorm room and threw out all alcohol and paraphernalia. It wasn't fun to be punished, but also, we felt lucky not to have been caught for more.

That night was another example of how I remained calm while everyone around me was panicking and responding. Instead of reacting when things became chaotic, I was taking things in and moving accordingly instead of simply running immediately. Many of my peers questioned this at the time as brave or stupid. It was simply a choice to take ownership and face the fire department so as not to burn that bridge.

～

Once I was nearing the end of nursing school, I was lucky enough to get an Emergency Department (ED) preceptorship (clinical hours shadowing/working with a nurse), which was rare at the time. Most preceptorships offered were on medical-surgical units. I loved this nursing rotation because every shift was unique, and there were opportunities for constant learning. Different illnesses and injuries

come in, and the staff holds a constant calm within the storm.

One day that stood out to me was hour eleven of a standard twelve-hour shift, with an additional hour to close out and finish any outstanding things. It felt like a typical day, busy but not totally underwater, when an ambulance team came running in, yelling for help. Four Emergency Medical Technicians (EMTs) were trying to hold a naked man on a stretcher. They were struggling, and some looked like they might even be physically hurt. More hands jumped in to help hold the man down and get the information on what was happening.

The EMT team and the police were called because a naked man was walking through a car wash. When they arrived, it was clear that the man had likely taken drugs, making it hard to communicate and get him to listen. The police eventually arrested him when he broke one of the officer's arms. Then more people stepped in to try to secure him. Fingers were broken, and the strength of the man became apparent. It was like he wasn't affected by any force trying to stop him from hurting others. It became clear that he was likely on Phencyclidine (PCP).

Because he was not stable and was not seemingly feeling pain—the protocol was to bring him to the nearest emergency department. The EMTs and some of the men from the unit tried to hold him down, while a doctor yelled orders. With a syringe filled with something that should knock a horse out, I approached the stretcher and gave him the medication, hoping to calm him down. When the initial dose didn't work, we had to do another. Finally, we got him to relax, making it possible to treat him and the injured EMT team.

During these three minutes, nothing moved around the man in the hallway—while at the same time—everything moved around us. The ED is a special place because nothing ever really stops. Things feel like they slow down, but only in the amount of focus that most of us who work there can get into. It's like each of us can emulate the calm in the storm. Nobody's in an outward panic, and nobody's losing their cool. We naturally slow things down within our bubble, making it possible to think clearly and communicate well with one another. It is a zone we access.

I can access this zone when things start getting crazy—it's almost

like the crazier the situation, the calmer I am while navigating it. It is one of my superpowers and one of my shortcomings. I don't tend to show much emotion the moment something happens. Instead, I remain calm until it's over and then allow myself to process it later, sometimes days or weeks later. This is something that my family and friends know about me, but it still sometimes surprises them.

I am the person pointing towards the goal, even when the storm is at its peak around me. Even when everyone else has lost their cool and given up, I am like a ship's figurehead as it whips through the waves.

My now husband and I broke things off a few years into our relationship. Things were hard at the time, it felt like we weren't making as much progress as we should have been in our relationship, and both of us lived and worked from home (this was pre-COVID pandemic), making it hard to take a break from each other.

It had been a particularly tough week, and we decided to end things. He packed a couple of bags and left with Banksy (our dog that started as his) in the middle of the night. I was heartbroken, totally lost, and shocked (I had thought he was the one—even then).

He moved to an apartment downtown, and I moved in with my best friend. When people asked me what had happened, I told them, "Love isn't enough." It's in communication, setting expectations, and people feeling seen and heard that things break down or thrive. These are all things that must be constant—not just one time or sometimes—this is what makes relationships hard work and worth it.

We obviously got back together, but before we did, we each did a lot of self-reflection. One of the many things I reflected on was my main goal in life. What was my inner compass pointing toward? What did I want & need out of a partnership? What hills would I die on, and what things could I compromise on in the future (regardless of who I was with)?

I could recenter myself slowly—with the help of good friends, family, and a strong will to succeed. I remembered my core values and

honored them. I chose to move through life intentionally—not settling for a lesser version of myself.

∼

Like Jack Sparrow's compass in *The Pirates of the Caribbean* film series, I can always find my true north (what I want the most). Trusting my gut, speaking my mind, listening deeply, all while being with an open heart—these are all part of my journey towards my true north.

My compass tattoo represents all of life's moments when things don't feel like they are going well. Regardless of how many seconds, minutes, hours, days, weeks, months, or years—I have this reminder to center myself during (which comes naturally to me) and after (which doesn't always feel easy) the storm—helping me keep my eyes on my true north and ride the waves as they come.

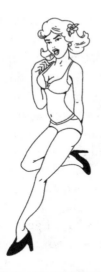

CHAPTER SEVENTEEN
THE PINUP

I got a tattoo of a modern pinup on my hip to represent me at my most comfortable and out-there self. Proud of my body and sex. It is a reminder to live life in full self-expression and to have fun throughout. A fantastic artist who met me and got to know my aura created the piece. She drew and selected the colors and the figure to represent me. It's sexy and modern—and it bounces to the music with me as I dance since it is on my hip.

Before my mom passed, she wanted to ensure I welcomed womanhood and all its glory. She wanted to leave me confident about my body, period, and sex. She spent a lot of time teaching me about my period, what it was, and how to manage it (a little early because she was sick). She also talked to me about sex and even how to masturbate (not in a creepy way). To help me in welcoming my womanhood, she enrolled us in a moon circle.

The moon circle was a group of moms and daughters all close to

getting their period (between the ages of 11-13.) We had different discussions on what it was to be a woman in a man's world and what our sex meant in this world. It was very hippie-dippie and very magical.

There were gemstones, bonfires, and dances. A trip to a yurt included a sauna together, all nude meditation and accepting our bodies. After sweating and struggling with the heat of this experience (I have always run hot and am only comfortable in a sauna short term), we left the yurt and danced the night away in big skirts that we made together around a bonfire. We had rattles that each mom and daughter pair made and painted together, and our voices - in combination, our music makers.

Only a handful of times have I genuinely felt as free as I did that night. I was truly accepting my body and my sex in ways that were hard for me to understand at the time. Seeing other women and girls— their flaws, scars, and glory, not giving a fuck about what anyone else thought. Being totally free just to be themselves in a safe environment, making it a carefree space, was more of a gift than I knew then, and I look back on it fondly.

My mom prepared me for things she knew I would need and taught me to take ownership of my body as I entered womanhood. This meant both swaying to the music if and when I wanted to while also being aware of my surroundings and safety. This meant knowing that I was in charge of who or what I wanted on my body, and saying no an acceptable response to anything I did not like. It also meant never feeling shame about my physical flaws as I am beautiful as I am.

≈

I lost my virginity soon after my seventeenth birthday celebration with a high school boyfriend I had been completely enamored with. Our first time was on a futon in his mom's house. It was awkward but also wonderful because I was ready and had thought hard about him being my first. After that, I first started to explore my sexuality; what did I like? What did I dislike? There was much to learn.

Several months later, he broke up with me while playing Frisbee

golf with our friends. I was brokenhearted and caught off guard. After properly mourning the breakup—remember, I was a teenager—I hosted a small party of eight people a couple of weeks later. We played many drinking games, including strip poker. I ended up hooking up (using protection) with someone I barely knew, loving the feeling that I had my power back. He and I talked for a very short couple of weeks before moving on from one another.

Soon after the party, I discovered I had Herpes Simplex Virus 1 (HSV-1). HSV-1 is a sexually transmitted disease that is chronic and common; well over 50 percent of the population had this virus in 2020, according to the World Health Organization. It was hard for me initially to take in—afraid of how it would affect my long-term relationships as it never goes away.

It was hard to accept because I had trusted these two people who had lied to me, as people apparently do about their sexual history. So, I told both parties, and they claimed that it had not been from them. But they both had sexual histories (come to find out) when I had thought my first boyfriend had also been a virgin. It was the first time I felt totally and utterly alone and like what I thought was real connection was not entirely, as we didn't have the same value of honesty.

I carried this virus and the value of honesty and moved forward in life, knowing that I would have to tell each person I encountered sexually and be even more careful with protection in all forms. I practiced talking about it to myself in a mirror so that I could get through it without tears and be able to answer any questions. I took a deep breath and pulled up my big girl pants—moving forward with more experience and awareness of how the world and people can be and taking responsibility for my impact on others.

After reflecting on how both relationships went for me, two of my significant conclusions were that sex was fun when practiced safely and that I was responsible for protecting myself. I moved into a stage of dating that was more "fun for now" relationships by choice. People around me questioned this at times, sometimes feeling like the person I was with at the time didn't make sense for me long-term (which, for me, was the point—you're only young once). Nevertheless, this was a

fun phase of life; the person I was really getting to know was me. I was learning my preferences and my non-negotiables.

Let me be clear; I'm not saying that we should all let loose with whomever, whenever, but I do believe in sex before marriage. For me, learning one's sexuality and accepting one's flaws is not simple. Asking for what you want, providing feedback, owning one's physical imperfections, and having clear communication are all significant life and leadership skills to learn and develop over time.

I was the girl who had a conversation about what the relationship was with each of my partners very early on. Some people thought this was aggressive, but most genuinely appreciated the clear definition and expectation setting that the conversation provided. There were a couple of relationships where feelings grew unexpectedly, and there needed to be another conversation. It turns out that continued communication is essential regardless of the relationship.

One of the many things I learned while dating these fun-for-now guys was what I did not want in a relationship. I experienced more than my fair share of manipulation and lousy communication throughout that learning.

There was a time on New Year's Eve that I was out with my at-the-time boyfriend in downtown Austin. We had gotten into a small fight about boundaries with other people and had decided to leave the party soon after midnight struck. We were walking up a sidewalk next to a building under construction, so the sidewalk had a tunnel.

In the tunnel, another couple was walking quickly behind us—we moved to a single file line to allow them to pass, but we were still in the way apparently because the man shoved me even further to the side so he could pass. I cried out as my body hit the side of the tunnel. My boyfriend started yelling at the guy—and they turned toward each other, facing off.

As they were yelling, the girl stared at me—with bruises on her face. Since the guy she was with just shoved me against a wall, it didn't

feel like a stretch to assume that he had put those bruises on her.

I said out loud, "Hey, do you need help? I know I don't know you, but ..." and before I could get the rest out, she punched me in the face.

I was shocked—I didn't see it coming and was confused. Why did she just hit me? I took the hit and stared back at her. Then, seeing only pain behind her eyes, I said, "You deserve better." She looked back through now visible tears as the male tugged her away, and they walked off.

I turned to my boyfriend, my face starting to swell, and to my surprise, he was yelling at me.

"How could you put yourself in that situation? What the hell were you thinking?"

The rest was a blur. Even more confused, I requested that we return to my place (we were in a long-distance relationship then, so it was also where he was staying).

We returned to my place, and I put ice on my face, still being yelled at for my stupidity and in shock about what had just happened. I lay there, my face becoming numb, thinking through his yelling, *Sami, you deserve better.*

Fast forward a bit, and I forgave his yelling because his apology seemed real, as he felt scared throughout the situation. A few months later, the yelling became more physical, and he held me against a wall by my neck while screaming, not really hurting me, and not hitting me but coming dangerously close. I knew then I had to get out of the relationship. I left his place with my suitcase hurriedly packed in the middle of the night.

My phone was dead; I couldn't call for help, so I hitchhiked to a nearby hotel, as scary as that sounded. Luckily, my hitchhiking experience was a smooth one. The person was very kind and even gave me water and a snack.

The next day, I left town again, and I ended things via phone once I was safely away from him. I knew this was not a healthy relationship and it didn't matter how good his apologies were. I deserved honor and respect, just like that girl who punched me in the face that year on New Year's Eve. We weren't that different after all.

≈

From a relatively young age, I struggled to see myself as beautiful. My body was curvier naturally than most. I had the gift and the curse of having large breasts and hips that don't lie. Even as an athlete, I was one of the bigger girls on the field. It was hard for me to look around and see others skinnier doing the same workout and eating the same food as me.

My parents were both athletes and healthy people to an extreme. My dad, a physician specializing in high-risk care of pregnant women, had/has strong opinions on being skinny and fit; he has a just-do-it attitude. He spent a lot of time when I was a teen and even today trying to motivate me to do more physical fitness to maintain my cardiopulmonary fitness and health.

His motivational push is one of his love languages, but it took me many years to understand this and not be too hard on myself. I have moments when he says something blunt that stings a bit, and I have to shake it off —returning to my pinup on my hip and dancing a bit until I feel better.

≈

One way that I have always channeled my confidence has been through dance. I loved to dance—it was a good workout and a fun way to express myself. So, every Thursday for years, while I was in school, we would dance the night away at the local club. It was in a dingy basement of an Irish pub. It was dark and crowded every Thursday because there was a dollar beer night just down the street, and the Irish pub caught all the drunk college students after they drank their share of beer.

I loved it—I was on a first-name basis with the bouncers and bartenders (though I did only a tiny amount of drinking there, as I am not skilled at drinking while dancing.) My mission was to let go of all hesitation and just let loose on the dance floor. Not caring what anyone else thought or what I looked like, frankly.

My friends would dance with me and help me fend off men who

approached from behind and tried to dance with me without asking. I occasionally would dance one dance with someone, but that was my limit—as I was not there to meet someone, I was there to dance. It's amazing how many men approached me when my ass bounced to the music. It was confidence-boosting while also being very annoying and disgusting. This was at a time in history when no one felt the need to ask permission before doing this the way they do now. People would just stand behind you and grab your hips. Sometimes they would even try to feel me up in ways that I didn't want, and I would have to stop them physically. Other times, someone would approach and show me they were hard, which is disgusting and always unwanted by a stranger.

I never left that bar with anyone I didn't come in with—unless it was a guy I was seeing or talking to who met me there. It was a magical place where my body and I completely aligned and all my stress fell away.

~

My cousin, Amanda, was engaged to a man (whom she didn't marry), and she asked me to be her maid of honor. I, of course, accepted, though I wasn't so sure the relationship was a good match.

I planned the bachelorette party to take place in Napa, California. I was so excited and happy to go to Napa. Amanda asked me if I was okay riding with her friend, also in the bridal party, from the San Francisco Airport to Napa. I accepted tentatively as I didn't know this person and was already feeling questionable towards her friend group.

This stranger, Lily, picked me up from the airport in her sports car and fancy clothes. She was also an extrovert and blonde. I got in the car and started chatting, immediately hitting it off. We aired our woes over the upcoming nuptials and the experience of the people we had met through my cousin. We drove for over two hours to Napa, and by the time we got there, we knew tons about each other and knew our relationship would be a long and great one.

Upon arrival at our rental condo, the woman who owned the place met us to give us a quick tour and the keys. It was during the early days

of short-term rentals of someone's home and was considered normal at the time. That said—in this case, we drove up to find a woman sitting on the stairs with a bottle of wine in hand, clearly having been recently crying. She appeared abnormally excited to greet us. She told us a long story of how she had just been tested for breast cancer and didn't know her results yet, and she needed some friends to party with her now! Lily and I looked at each other and silently agreed—we would be her companions for a while. We had a few hours to burn before others would arrive and were up for the adventure.

So, Lily and I went winery-hopping with another stranger, Patricia—this woman knew everyone, and we drank for free everywhere we went. Getting pretty toasty by the time my cousin and others arrived to meet us. They quickly caught up, and we had a crazy dinner experience. Honestly, in our condition, the winery staff probably shouldn't have served us. We were singing loudly while throwing arugula into the air, and one girl was flirting with the busboy in astonishing ways. It was a wild and early night.

The following day, we continued our wine tasting in a more proper manner and ended the night in downtown Napa to dance, where we ran into our rental property owner and her boyfriend. They joined us, and we partied once again together. Dancing and laughing the night away. The following day—needing water and bagels, Lily and I admitted our love for one another while lying in bed (we were each sharing a room with another person as there were more of us than beds), and then I went to get everyone breakfast. We both knew our friendship would be epic from then on, new best friends taking on the equivalent of an adult Disneyland followed by life!

The following day was only slightly tamer—we went out and sang and danced as always. This time, we stayed closer to home and ended the night in the rental condo. It was an amazing final night of our three-day weekend.

Upon checkout, the owner and her boyfriend proposed to me that I was welcome to stay in Napa and live in the house we had rented for free if I wanted to join their relationship, making it a trio. I politely declined and left with my cousin and her friends, hesitating only

because I was leaving Napa with it high on my list as one of my very favorite places. Lily and I still laugh about this today—politely naming it "the Napa three-way offer."

~

I have always considered myself a lover of people. Any and all people— finding myself attracted to certain humans not defined by sex. Both women and men have sexually attracted me. I have dated more men than women and would say that I lean more towards men overall, but the line is not a hard, bold line for me, and I don't feel the need to label it.

When I was in my fun-for-now phase, I dated a woman who was a close friend of mine for a few months. This was actually accidental as I didn't know her intentions and thought we were just friends. We hung out often and had sleepovers. In my mind, she would stay over because she lived far away, and we would drink together. In her mind, in hindsight, it was a show of affection and progression in our relationship.

Our friendship formation was very easy, and we had a lot in common. We worked together and genuinely enjoyed each other's company. We started hanging out outside of work with our coworkers and then one-on-one. We enjoyed many of the same things, like horseback riding and building wood furniture, both of which we did together. We both had dogs we loved dearly and enjoyed wine.

One night we had been drinking and had had a great evening together building a piece of furniture. We moved to my bedroom to crash for the evening—when suddenly she kissed me. I love humans and kissing—I also was intoxicated, and a little surprised, so I went with it. We made out for a while, and eventually, it became more. At the end of our "fooling around," I apologized for not being good at this because it felt like the right thing to do, and I was becoming aware that I had crossed a line I should not have crossed with her as we had never had a conversation or expectation setting of any kind.

We went to sleep, and I woke up not knowing what to do next. Our

friendship had shifted dramatically in a way I didn't intend. I knew that I had messed up by allowing things to go the way they did and that I should have clarified my position when things were initiated on her end, but I didn't. We went to work and agreed to talk about things after our shift.

We went to grab food next door to our workplace and talked things out. I expressed that I thought we were just friends, and she took offense to that, and shared that she thought we had been dating for months.

I pointed out that we hadn't even held hands, and she pointed out that we had done romantic things together, like build furniture and go to the movies and she thought physical touch just wasn't my thing. I pointed out that I had talked openly about my sex life with her, and she pointed out that she was okay with me having sex with others and that she thought she had made that clear.

After more back and forth, she started crying and screaming mean things at me before storming out. She left me crying in silence, knowing I had truly hurt someone I loved but just wasn't attracted to in that way.

This was a big lesson for me—I had never gone into a sexual act with someone before being clear about whether we were on the same page. I had never had to have that kind of conversation with a woman. I had never had to face my wrongs in quite that way, and I genuinely, even today, felt bad about leading her on. She was a fantastic human, and I was the asshole of this story. I walked away from it reasonably unscathed, though our friendship had taken a big hit.

Over time, our friendship was repaired, and months later, we were taking Jell-O shots with the guy I was sleeping with casually, leading to a threesome opportunity. I couldn't believe it—a threesome had always been something I was curious about but couldn't see my way into because the relationship would have to be just right, with no strings attached for anyone involved. These were two people I had been sexual with before, so it felt more than perfect.

We moved up to the bedroom, but I was too intoxicated. I fell asleep naked next to them, having sex, missing all the fun and the one chance I had encountered to have a threesome with no strings attached.

Ultimately, it's a shame I slept through it, and I am grateful that our

friendship healed, eventually. These lessons also helped me to realize that I ultimately saw myself with a man as my partner and to be more careful not to lead people on in the future.

~

Eventually, I grew tired of the fun, for now, exploration and longed for a deeper connection with a partner. I wasn't willing to have a serious, monogamous relationship with just anyone, and I felt I established what I didn't want from a partner pretty well. I knew it would take time to find the right person for me. So, I started looking for a man who understood me deeply, supported my dreams and goals, was great in bed, successful, driven, and sexy—yes, I wanted it all.

It took years for me to find someone who ticked all my boxes. I was starting to feel like the man I was looking for was from a fairytale. But then I met my husband.

And the rest is history.

So, rightly so, my pinup tattoo is on my hip—she was drawn for me by an artist who took some time to get to know me and my presence. She is me and my sexiness. She is me letting loose. She is beautiful and unafraid.

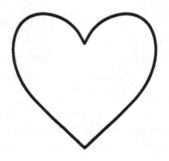

CHAPTER EIGHTEEN
THE HEART

Being open to others' hearts even when they are hurting or different from you—remaining open and willing to let love in and experience others at their full self-expression without assumption or judgment—wouldn't that be a beautiful world to live in?

Some of the best conversations I have had with people have been the ones that are totally random one-offs. One of my favorites was my conversation with a stripper giving me a lap dance while talking about a massage therapist she loved. How I found myself having this conversation is a long story that I will make short.

I was a server after nursing school while figuring out what I wanted to do with my career. There was a couple who were regulars at the restaurant where I worked that I would serve around once a week. The guy was an ex-football player—they usually tipped well. One night, they asked me and my roommate (the bartender) if we wanted to join them at their table at a club.

I said yes, and we would love to, before finding out the club was a strip club. Luckily, my roommate was a great friend of mine, and she agreed to come with me.

Back to the stripper conversation—this woman and I talked about back pain from having large breasts. You know, the typical stuff that gets discussed during a lap dance. She told me about a fabulous massage therapist she and the other girls regularly visited.

The part of the story that hooked me about this masseuse was that he provided a massage until he felt your body was ready to go out into the world again; this meant he did not time the session. He also didn't charge in a typical way—he allowed you to pay whatever you could or thought the massage was worth. This sold me, as I was living paycheck to paycheck and really needed a good massage.

She gave me his phone number, and I called to confirm what she told me. He said it was true, so we set a time, and I met him at his home.

I was a little nervous but ready and going in, eyes wide open (self-awareness high to make sure I was safe). I knocked, and when he opened the door, I immediately relaxed. He was wearing a tie-dye t-shirt, round purple sunglasses, long locks, facial hair, no shoes, and parachute pants. He was much shorter than me and skinny. In other words, he was not a scary-looking person with whom I felt unsafe.

He had me follow him to his massage sanctuary. We walked into the house filled with boho things and laid-back vibes. We got to the massage sanctuary, a beautifully lit room with a massage table in the center—surrounded by greenery—it was like entering a greenhouse without the heat. He told me to get undressed to my comfort zone and asked how my body felt. He left the room to give me privacy, and I got ready for my massage.

Several hours later, I had a great massage—not sure what time it was or how long I had been there, feeling uncomfortable with how comfortable I was. He gracefully stopped messaging me, and things became quiet for a minute. I wondered if it was over and whether it was time for me to get up (I was face down, so I couldn't see anything by just opening my eyes). I decided to start counting the seconds to make sure I didn't get up too fast (my plan was to count to two minutes), as I

was unsure if he was still in the room or not.

As I reached around a minute and a half, there was suddenly a sound, a wind instrument that I recognized the sound; it was a didgeridoo (I knew this because my brother had one that he had bought during one of our trips to Australia). It started from one corner and then moved all around me—it was like the player was dancing around the room. I tried to enjoy it but was still unsure of what was happening. Then, all of a sudden, it stopped. It was silent again, and I started counting again, telling myself that if nothing happened after three minutes, it was safe to get up.

Three minutes passed, and I lifted my head. I glanced around the room and confirmed I was alone. I got up and got dressed quickly. I checked my phone to see what time it was and grabbed some cash to give him for his services. I started looking for him and couldn't find him, becoming uncomfortable walking around someone else's house; just as I was about to give up, I spotted him—he was meditating (surrounded by peace signs) in his courtyard. I paused and decided not to interrupt—went back to the massage sanctuary and left the cash on the table. On my way out, I passed a room with dozens of didgeridoos and wondered why he had so many.

Before our next massage—because yes, it was that good—he shared with me that he went to Burning Man (an event held in the desert that brings community together through art, trade, and connection) annually and traded massage and didgeridoos for other things and services—his preferred name was Magic Matt.

My conversation with Matt is another example of where a good conversation with a stranger can lead you. I advise making the most of each interaction, not just because of what could come from it, but also because you never know what you could learn about someone. First impressions are often wrong, and assumptions we make are more about us and less about those we assume things about. Learning how to stay curious and enjoy the conversation with those you interact with throughout your day can only serve you in learning, humility, and sometimes even great massages.

I also want to highlight safety—I had a friend with me and others

that knew where we were and who we were with when we went to the strip club. When I went to see Magic Matt, I was hyper-aware of my surroundings, ensuring I always felt safe and again, people knew where I was and there was a plan in place for quick communication if necessary.

I don't want anyone to confuse living in the moment with carelessness. I will be the first to tell you to be careful; not everything or everyone is what they appear to be.

Watching, and being aware of another's breath, might be the closest experience you can have to witnessing someone's heart on their sleeve. If you pay attention to someone's breath, you can see how they are really feeling. You can then meet them where they are and practice genuine empathy and compassion for someone else's experience.

It's hard to hide how you really feel in your breath—and at the same time, your breath can calm you in the moments when your brain can't get there by itself. The times your heart feels like it is literally breaking—when your body aches and all you can do is breathe.

After Jacob's death (our close family friend), my parents told us the news first thing in the morning, they were still in bed later than normal, and Michael and I had gone up to wake them. They asked us to sit down before they shared the news. We cried and asked questions, and finally, we all cuddled up in bed and lay there tired from our tears. My parents were especially exhausted, as they had been up talking with people about Jacob throughout the night.

As we lay there, I was having trouble being calm, laying still. My mom wrapped her arms around me and said, "shhh." I knew I was being disruptive and wanted to find a way to calm down. I started focusing on my mom's breath—her chest moving up and down—I could feel her breath rise and fall as we lay there. Eventually I calmed down enough to match her breathing, even getting lost in the difference in the length of each of our natural breaths. Slowing mine to hers and releasing the sadness and anger I felt that were making me restless.

Leaning into this form of what I now know to be called

meditation—I fell into a deep sleep, waking an hour or so later feeling calmer than before. There are many ways people express their love and emotions in each moment. There is a saying that people say, "wearing your heart on your sleeve," which means someone is openly showing their emotions or feelings. I think there are examples of this in people, but it's rare to meet someone willing to show their whole selves—pain and all.

~

One of my friends, Mary, was a friend I met on campus during my freshman year of college. She called me one day a couple of years later to explain that her life was in shambles and that she needed a new start. We stayed in touch and even traveled together through Germany, Latvia, and Estonia. Mary was someone I trusted more than many other friends. I invited her to stay with me for a while in my apartment in Austin, as she needed to get herself back on her feet.

After a few weeks of crashing on my couch, we discussed what she wanted to do with her future. What did she think that getting back on her feet looked like? We decided to find a bigger place so that we could officially be roommates since she wanted to stay in Austin and find a job. We found a huge house with four bedrooms with a massive yard. The house seemed perfect. We brought in a third roommate, a coworker of mine, and all moved in. It was the three of us and two dogs.

It went well for a while. We had jobs and were getting by okay. Yet, a few months later, my life with my new roommates started getting more complicated. Mary lost her job; she told a story about why she couldn't work there and that she had a plan for her next job that seemed legitimate. She interviewed and got another gig as promised, but wasn't making much money. Here and there, I covered expenses for her, like dinner or gas, with her always promising it would be a loan. She would occasionally pay for things for us both when she had the money, adding trust to the situation from my side.

One morning, I woke up to the sound of a tow truck. Looking outside, I saw Mary's car get towed away. She came and told me her

story, explaining that she didn't have the money to pay for her car loan or to get her car back from the impound. We talked it out, and I agreed to help her get her car back, again with the promise of it being a loan. I started picking up extra shifts at my restaurant job and even got a credit card to cover the cost of getting the car back. My reason was that without the car, she wouldn't be able to get to work and wouldn't be able to pay rent.

Mary was a close friend of mine, so assisting her felt like the right thing to do. It was the kind of help that all people should have access to, and I felt it was the least I could do. I also had the ability and flexibility with my job and finances to get a decent credit card and pick up shifts – which I was very grateful for at the time.

Slowly, things got worse. Her share of the rent was not being covered, and I kept paying it because my name was on the lease, and I didn't want my credit to be affected. Eventually, I was in a position where I was looking at about ten thousand dollars of help accumulating over time, some of which was debt. I realized she would never be able to pay me back, and it was unlikely to change. Every conversation she and I had was difficult. Her reasons for not having enough money were real reasons that many people struggle with on a daily basis. She wasn't making enough to cover her large bills, her car loan, or food and gas money. I knew this was true, but didn't know how to help her get a better job.

After talking in circles and witnessing her time applying to other gigs, I hoped things would turn around. I said yes to helping her one last time. Yes, when I should have said no. The weight of her financial troubles was too great for me; I didn't have the money either and was going into debt trying to cover things, which is never a good idea. I knew something needed to change.

Through tears, I sat her down and told her she needed to move out and into a more affordable living situation. I explained that I couldn't cover her expenses anymore, as I wasn't successful enough for both of us. It was the most challenging conversation I'd had to date. I felt I was failing her. Just like the system fails many. I wanted so badly to be able to help her, trusting that she was a good person just trying to get by; it

was hard to live with the fact that I couldn't help anymore, not in that way.

She also cried — hugged me and thanked me for what I had done. She moved out soon afterward, and I found another two roommates (a couple) to take her place in the house. We no longer talk. I had a difficult time after that trying to get my own finances back on track. Part of me resented her for putting me in a crappy situation, and part of me was disappointed in myself for allowing debt to build up over time.

Years later, only after my own form of bailout, did I get to a place where I could start saving money instead of adding debt. To this day, this was not a fun lesson to learn; no matter how much you may want to help someone, sometimes you can't without hurting yourself.

I strayed from my own goals and dreams while trying to help Mary, and I lost sight of my future and joined her in the day-to-day getting by (and we didn't even do that well). Not only was I unable to help her, but I also put myself in a position of setback. Knowing when you are straying from your own path can be challenging. Sometimes it feels like your values conflict. In this case, my values of friendship/helping others and getting myself, my priorities, and my finances off to a good start conflicted. It made the decisions harder than when you don't have values directly opposed to one another.

My advice is always to think short term as well as long term. Slow down in the moments where your values are in conflict and assess what is best for your present and future self. Own your shit; don't make excuses for yourself as to why the bad forms of debt will be ok over time. They aren't and you are only letting "them" win by not falling on your own sword and taking proper care financially.

~

My heart is in my chest, just like every other human—but it is also visible in my breath and on my foot. I got a heart tattoo on my foot that reminds me to be with my emotions, whether big or small, but also to never be afraid to share how I'm feeling with those around me. It reminds me not to guard myself too much and let love in, especially

during hard times and especially when it is love for myself. It helps me ground myself back to my breath—until I'm ready to talk, think, or be in the present again.

The heart tattoo is on the inside of my heel to represent the balance of my heart. I believe in living life as fully as possible, which means being able to be in full self-expression. Caring for yourself and others in big ways and also keeping an eye on the dreams you have yet to reach. Caring loudly (in obvious ways/actions) while not losing sight of the bigger picture. My heart is there to help me remember I am responsible for my impact on others and myself and to always be aware of the balance between the two.

Many of us forget that it is okay to feel things outwardly—especially as we grow in our careers and others take us more seriously. Part of being human is feeling all feelings, from anger to joy—none of these are less human than the next. We are taught to tamper down emotions as we age and enter the workforce. While this can benefit us, I believe it can also hurt us. There are healthy ways to have all emotions, including anger and sadness. Learning how to wield tools that help us to feel without lashing out at others is part of growing our leadership and something I continue to work on as I learn and grow.

Feel things fully and then decide intentionally how you want to move forward. Life is short and undetermined, and you can live it in your own form of full self-expression!

CHAPTER NINETEEN
THE XX'S

Two xx's one on top of the other is the Viking symbol Inguz, which means the symbol of completion, abundance, fruitfulness, and my favorite, "where there is a will, there is a way."

The saying is literal for me. Another way of saying it is "if the why is great enough, the how will become clear." Both of these mean that persistence and hard work can get you anywhere you choose to go. Being clear on what you want to do is the hard part. Once you have done that, everything else will fall into place.

As I stumbled around before applying to nursing school, I applied to become a Los Angeles Police Department (LAPD) officer. I didn't live in LA, but California was a place I frequently visited, and the LAPD seemed like the best of the best as far as police officers were concerned (according to television crime dramas).

I applied and got accepted for an interview faster than I could process.

As soon as I hit submit, I started questioning myself. *Why am I doing this? I don't even like cops. —I have a record of speeding. What's my goal here?* The answer to all those questions was that I didn't believe in myself and my ability to get good grades and a great corporate job.

However, I believed in my physical strength and knew I could pass a physical exam. Becoming a cop seemed like a better idea than joining the military.

I took the interview and quickly passed along to the next phase to take the physical exam. I flew to LA and crashed with my cousin. I panicked as the day got closer—suddenly, it was tomorrow. I didn't want to be a cop. I didn't want to wear a uniform and carry a gun. I didn't want to be a good guy, a bad guy, and nothing in between.

I skipped the physical test, taking my name out of the running to become part of the LAPD. I had ruled out the idea that I was okay not finishing college and knew deep in my soul that I had to get better grades and work my ass off to reach my goals. So, feeling more grounded than I was upon my arrival, I got back on a plane and flew home, looking down over the lights of LA, thinking to myself ... *Nope. Not for me.*

～

After my bad first semester of freshman year, my grades left me with a 2.0 GPA. I fought the rest of my college career to bring this up. In hindsight, I should have transferred schools after my first year—taking my credits and not my grades. I wasn't lucky enough to have anyone advise me that this was an option; I thought I had to stay where I was and work on raising my GPA one class at a time.

I decided I wanted to attend nursing school, which required a certain GPA. I realized that I would have three semesters to raise my GPA from 2.0 to above 3.2, which was impossible, even if I could get all A's from then on. I did get very close to the required GPA, but not quite there. I decided to apply anyway and quickly heard that I was not eligible.

Incredibly disappointed, I worked on figuring out what to do next. Eventually, I got to where I knew I wanted to apply again. I had a year

to make my application more robust. I interned overseas, volunteered in multiple ways, and worked hard to get the best grades possible.

When the application time rolled around again the following year, I started my essay by sharing that I knew my GPA wasn't there (I was so close but still off) but that they should give me a chance anyway. I wrote about why I wanted to be a nurse, what I had done that was special, and even my missteps that led me to a bad GPA. I poured my heart out on the page and then had my dad and stepmom edit it—making it even better.

It was a killer essay about why they should let me into the program, but I thought it was a long shot and didn't expect to hear good news. It took forever to hear back, and finally, I received a call asking if I would come and meet with one of the staff members. I agreed, unsure why they wanted me to come in to meet with their staff member, but also glad they hadn't turned me down yet.

I went in nervously at the scheduled time—feeling as if I was going to meet with the principal and they would tell me to stop applying. They called me into an office and sat me across from a serious-looking professor.

She then explained to me that three professors review each application to make sure that multiple people are providing their vote on each application. Some people get in by simply having all three vote yes. Then some applications have "Yes ... but let's discuss," and there are split votes.

I was one of the applications that year that had "Yes ... but let's discuss" from all three professors that reviewed my application. When the whole group met to discuss the applications and the spots left— they talked about how convincing my essay was and thought I deserved a chance in the program. I couldn't believe it as she told me this story, but I still sat nervously, waiting to hear my fate.

She finally finished, looked me dead in the eyes, and said, "We want to accept you into The School of Nursing BSN Program, but you will be put on probation immediately."

I stopped breathing, stared back, and said, "What's probation?"

She explained I would be required to get a B or above in all my

future coursework, and they would remove me from the program if I didn't—but otherwise, I was accepted!

I said, "Yes, please! I will not let you down!"

She smiled back at me, congratulated me, and sent me on my way. I left the building and burst into tears. I called my dad, told him the news, and ran back to my apartment to celebrate with my friends!

It was a massive moment for me—I had proven to someone other than my family or friends that I was worth it and that I deserved a chance. I had stood up for myself—what I had done and wanted to do, and I was going to start nursing school!

Persistence and hard work made one of my dreams come true!

After finishing my MBA, I searched for more meaning in my work. I was in my late 20s and wanted to have a short and long-term impact when helping people. One day, through a conversation at happy hour, I leaned into trusting my gut and best friend when I felt like there was more that I was meant to do in this life than the work I was doing at the time. My best friend Ana suggested that I might like coaching. She had done a coaching program with the Co-Active Training Institute (CTI) many years before we met and used it daily in her work, both in the corporate world and as a side hustle. She was, and IS, a badass, and I trusted her more than I trusted myself in many ways.

Not fully understanding what I was getting myself into—I signed up for the same program to take the first of five courses. They immediately picked me to be part of the first demonstration on day one. I went up to the front of the room as I was to play the role of the client. I answered questions as truthfully as possible and awkwardly went through the demonstration; it was my first time being coached in this way. At the end of the demonstration, everyone was in awe, and I was still processing—and confused—about the demo's whole point. It was hard to both be the client and critique the situation. The coaching wasn't mind-blowing to me, but based on people's reactions, I could see in others and felt immediately that it was different from a typical

interaction between two people.

Throughout the rest of the day, we all fumbled around, trying to ask only what and how questions and remaining curious. It was hard, but damn, did it feel good. It was like I had finally found something I was naturally good at and genuinely liked. I did the rest of the five programs as quickly as possible, soaking it all up and then going through the certification process.

To get your final certification, you had to pass an oral exam. During the oral exam, you were to coach two different certification coaches. It was terrifying, and I didn't pass the first time. Or the second. I stressed myself out and questioned why I was doing this and why it mattered to me. I fought through many negative thoughts on whether I deserved to be a coach and if I was going to be a good one.

Eventually, I asked two of my peers for help. They jumped on a call with me weekly and practiced with me. I coached one and then the other and received feedback. The goal was to make it so I could no longer be nervous about the exam. It worked — I crushed the exam the third time, and it felt so good. Even more impressively, I had proved to myself I was good enough to be and do what I wanted in this life. Again, proving that sticking with something and being open to growing, developing, and failing produces good outcomes.

Now, I have my own business. I coach emerging leaders. What this means to me is that I coach people at all levels of leadership that are in a period of growth and development, whether they are working to prepare for the next job transition or want to grow the company's culture. I love coaching people who are hoping to level up themselves!

I also have a consulting arm to my business in which I teach leadership development skills to teams with a business partner I love working with, who is a friend and ally, regardless of what we are trying to accomplish in this life. We create workshops that help individuals become stronger leaders to catalyze highly effective teams. We then lead these workshops, amplifying what a team can do together through contextually based experiential learning (no lectures) workshops. We use our coaching and leadership experience to improve individuals' leadership skills, like active listening, self-awareness, feedback, and

resilience. The result is transforming teams to be more effective and high performing.

I love what I do, as it aligns with what matters most to me, amplifying the connection with oneself and others. It results in the kind of impact I want to have on the world, and I am thrilled to be able to practice it each day.

~

I got the Viking symbol Inguz (two xx's) tattooed on my foot. The tattoo, for me, represents being grounded in my choices and trusting in my gut. There are many moments in life when self-doubt becomes loud and hard to look past, and my xx's are a reminder that I've got this in those moments.

CHAPTER TWENTY
THE FLORAL WORK

Sometimes relationships can feel like you are building a brick wall with someone else, placing one brick at a time, trying to line each brick up perfectly with the next, and occasionally having to take one off and replace it. It takes patience, curiosity, and listening, all extraordinary leadership skills that translate to all things in life!

Russell and I are now on the most incredible adventure of all together, growing our family from two humans and two dogs to the same, plus some small humans. We want a couple of kids and are excited to be parents. Becoming a parent feels like it is both impossible and simple all at the same time.

One of the big lessons I continue to learn and let in is that each part of life and putting down roots can be a different form of adventure. It might not be getting a massage by Magic Matt or skydiving, but it is undoubtedly still exciting and full of adrenaline.

~

Have you ever had an adventure where a dog was in the lead? Well, I

have. When I was between three and four, I visited my grandparents' house in Roanoke, VA. I wanted to play in the yard with their dog, Molsen, a golden retriever. My parents, grandparents, aunts and uncles, and brother, who was not even one at the time, sat on the porch and could look down to see Molsen and me. After playing in the yard for a while, Molsen started to walk away from me. Naturally, I followed.

My mom looked down to check on us, and we were nowhere to be found. In a panic, all the adults set out on foot, looking for a golden retriever and a little blond girl, yelling our names to no avail. After a while, they started driving around to look for Molsen and me.

Suddenly, someone spotted Molsen sitting on a distant neighbor's front porch. They stopped and knocked on the door of the house and found me sitting at a kitchen table eating Cheerios, having no idea that people were looking for me. The man who owned the house asked my parents to prove that I was their child, and the cops came to verify this before he felt comfortable giving me back to my family.

The police also did their due diligence to ensure I hadn't been running away from something or someone dangerous at home. They interviewed my parents, grandparents, me, and the man who gave me Cheerios. The man who they found me with told them that he thought it was strange to see a young girl and a dog walking down the street with no adult in sight, so he asked me where I was going and where I was from—to which I said "We are on an adventure" and "I'm from Utah." Remember that we were in Virginia then—so that was surprising information. Then, he asked me if I was hungry, and I said, "Yes! Cheerios, please!" So that's how I ended up there—he was calling the police at the same time the person saw Molsen on the porch and knocked on the door.

I still have a copy of the police report that includes my interview. It reads:

Officer: "Sami, where were you going?"

Me: "Molsen wanted to go on a walk, so we did."

Officer: "How did you cross the highway?"

Me: "Well ... Molsen doesn't have hands, so I held onto the thing around his neck."

Officer: "Why did you stop here?"

Me: "He has Cheerios."

My mom was grateful I was safe, but the experience also horrified her. She immediately threw out all children's books with dogs and children going on adventures without adults and talked to me about not leaving where I was supposed to be without an adult or permission. I agreed, of course—still surprised by how upset everyone seemed. I hugged Molsen goodnight and whispered, "Thanks for the adventure."

Many years after getting my Peter Pan tattoo, "To live would be an awfully big adventure," I decided I wanted to add a sort of frame to it. I chose beautiful flowers to wrap around the quote, not changing the words at all but making the tattoo more complete and showing the growth that had taken place within me through time.

\sim

Over the years, I have learned that there is also a lot of growth in staying instead of running, staying instead of hiding, and staying instead of fighting. Throughout my younger years, I often had plenty of reasons to run, hide, or fight instead of remaining open and curious. Sometimes those things served me better than staying, but there were times when staying was likely the more difficult thing but also the right thing.

The day I realized that Russell would be my husband was not just a big day for apparent reasons but also a big one for my growth, because I chose more for myself than I ever had. I was doubling down on love and putting down roots. It was a strange day for me, to say the least. But it was an epic agreement to stay.

I woke up that day and looked at Russell, who was still asleep. For whatever reason, seeing him that morning was different from the morning before, and I felt like I belonged next to him in a different way. It was me shifting to a more open place with him, I know now, and I had realized that he was really good for me (truly believing in me). He supports me through all of my crazy dreams and pushes me to do and achieve more than I ever would have thought I could.

He and I, at times, can feel like oil and water because we are both as

stubborn as they come and passionate about the truth. But, sometimes, the truth doesn't matter as much as how you get to it. We have tested each other (subconsciously and consciously) and are only stronger because of it. Even when times were tough, staying instead of leaving was the greatest respect we could give one another and our relationship.

I wanted to create a family with him, and it scared the shit out of me. It felt like I was gaining so much while also letting go of so much. I had been Peter Pan and grown into wanting to plan for a future—my future. I was choosing life over death once more and deciding to begin a different kind of adventure.

It was many months before we got engaged, but I knew that day— my life was different, and I was grateful to have grown in these ways.

~

I got this floral work done by a fantastic artist who studied tattooing in the US, Canada, and China. They do what is called freehand tattooing—this means that they do not use preliminary drawings, and you have to trust in the process. They respond to your body in real-time and practice mindfulness while tattooing, which resonates with my idea of *"come what may."*

They are an incredibly talented artist, and my floral work could not look better or capture life's adventures more. I had to make getting this tattoo an adventure too, and I loved not knowing what it would look like, leaning into the artist and trusting their process. Knowing they were extraordinarily talented and open to whatever came from their creative genius that day.

Adventures and living in the moment remain values of mine, from finding cheerios at that man's house to today.

CHAPTER TWENTY-ONE
THE HUMMINGBIRD

We had a section of the mountainside to one side of our blue log cabin seeded with many random wildflowers. When they bloomed every summer, it was epically beautiful. Every color you can imagine on this mountainside and every flower bloomed freely in chaos. I loved this time of year.

My favorite thing was lying down in the wildflowers—looking up at the sky through all the flowers' colors and watching bees and hummingbirds buzzing and flitting around me. We had several hummingbird feeding stations hanging in red feeders on green stakes. We placed them throughout the wildflowers, adding to the ambiance and my view while I basked in the sunlight (covered in sunscreen and other sun protection, as I am very fair-skinned and, at the time, a toe head).

The hummingbirds and bees were magnificent to watch; they seemed simultaneously very busy yet had nowhere to go. Similar to how I felt while taking it all in at once—overstimulated by the nature, insects, and animals surrounding me and loving it.

~

I also have many childhood memories of birdhouses and hummingbird feeders. My mom and dad both really liked the birds that lived up the canyon with us. My mom found unique birdhouses to place all over the house and the property—some for decoration and others for actual birds. My dad picked up bird watching and loved learning and talking about birds.

There was an old, tall, chest-like wardrobe in our foyer with many birdhouses on top (equally as intricate). I used to go inside the wardrobe and imagine my life as a bird living in one of the houses. I pretended that the tall chest was a birdhouse and the birdhouses on top were my neighbors.

It was a fun game—taking ideas from *The Lion, the Witch, and the Wardrobe*—and other stories. My imaginary world was full of animals, nature, and the humans I loved. There were still scary things like villains, but the good outweighed the bad. Being a bird in my imagination looked fairy-like—probably inspired by Peter Pan. I communicated with the humans and fought to keep nature alive.

It was magical, and the birds living in the canyon were fascinating, connecting our family through bird watching, bird feeders, and more.

~

When Michael and I were kids, we often went birdwatching and plane-throwing with our dad. We had various planes over the years that we would take to the top of the mountain and throw off—watching them glide down Little Mountain and trying to track where they landed. We would then make our way down the mountain to find the plane, either running, sledding, or driving, depending on the season and how far the plane went. We'd bring it back to the top of the mountain to go again. It was like we were playing fetch with ourselves.

The planes were pretty cool—for kids our age. One of my favorites, and one of the ones we had for the longest time without breaking or losing it, was a huge Styrofoam glider. Watching it glide down the

mountain, surrounded by nature and animals, was so much fun.

My dad always brought his binoculars—binocs for short—to watch for birds as we did this routine. We would point one out—he would look and try to figure out what it was—finding things like house sparrows, red-tailed hawks, and lazuli buntings. It was both fun and really dull, depending on the sighting and the time between actions. Michael and I would run around and play when we weren't throwing the plane while Dad looked out across the reservoir and mountains finding birds.

~

I knew I wanted to get a tattoo representing my childhood experiences that stood out so vividly in my memory. So, I decided to find a way to build a tattoo that included flowers, a hummingbird, and a lazuli bunting. I met with the same artist (they/them) that did my flower addition around my Peter Pan quote, and they created something unique for me on my shoulder.

Again, like the flowers around my quote, it was a tattoo I could not try on or see an example of before the artist completed it. They combined anemone flowers with a hummingbird and a lazuli bunting wrapping around my shoulder in an incredible dot work style.

Anemone flowers grow in temperate and subtropical regions in most places worldwide. They are also commonly used in bridal bouquets as, in some cultures, they symbolize fertility and even Aphrodite. In others, they symbolize losing a loved one or ward off bad luck. There are many different versions of what these flowers represent in different cultures. My favorite meaning is somewhere in between the death of a loved one and Aphrodite. But I am a paradoxical person happy to have both represented on my body.

The lazuli bunting is a North American songbird. The males are blue and white with light rusty breasts. The females are, of course, brown and white/gray—it's a bummer to me that female birds are not colorful, but that's how it is. The bright blue males were easier to spot when we were birdwatching, and I loved the song they made.

Hummingbirds are simply fascinating. They can beat their wings at a clip of forty beats per second—making almost a humming sound while they fly. They can move in all directions quickly and are the only birds that can move backward during flight. They weigh less than a nickel, and a flock of hummingbirds is called a bouquet. I mean, come on—what's not to love?

Ultimately, while many things are represented in this tattoo, I think of mostly my dad when I see it, as it represents the good times in our relationship.

CHAPTER TWENTY-TWO
THE SAK YANT

For my thirtieth birthday, Russell told me I could pick a trip I had been dying to go on, plan it, and we would be off, as his gift to me. This was a big deal for a few reasons—first, I didn't have to save money to go. Second, we travel differently, so doing everything I wanted to do the way I wanted to was a big deal. Third, I mean clearly, I was being spoiled by a partner who loves me.

My biggest bucket list trip at the time was Thailand. I wanted to island hop via a long-tail boat and swim in the Gulf of Thailand, see monkeys on the islands, and drink drinks with straws in them. I wanted to go to flea markets and night markets in Bangkok, get a Thai massage almost every day, and get a Sak Yant tattoo and explore Buddhist temples. I wanted to see Elephants in their natural habitat and breathe in the Thai air. I wanted to learn to cook curry and Pad Thai. We had a week to explore and went from Krabi to Chiang Mai to Bangkok.

It was an epic trip.

My Sak Yant tattoo was one of the most exciting tattoos I have ever gotten. Sak in Thai means tattoo, and Yant is Yantra, meaning sacred design (in short). The sacred design includes ancient symbols

and geometric elements; sometimes, it includes animals or Buddhist psalms. These, in combination, evoke various forms of protection, luck, healing, or strength. What gets put into the tattoo depends on your conversation with the Buddhist Monk, who traditionally provides this kind of tattoo.

Russell was willing to come with me for my Sak Yant experience, but opted out of getting one himself. We got picked up from our hotel and taken to a small Buddhist temple that the Ajarn (which means master/professor/teacher, in this case, master of Sak Yant) worked out of, and the locals could attend anytime. Upon arrival, you are asked to make an offering, which can be cash, flowers, and otherwise, in exchange for the free Sak Yant experience that the travel guide would pass along to the Ajarn, as you do not directly communicate with the Ajarn outside of the sacred encounter. Before entering the temple, they gave me the chance to pray.

I knelt in front of the temple and held incense while thinking about what had led me here and trying to connect with my mom in the spiritual world. I then cleared my mind of all thought and took a breath. We were told before entering that we were not to maintain eye contact with the Ajarn or show signs of disrespect while there. Then we went inside.

We sat in front of the Ajarn, who asked some questions through our travel guide. Some of the questions were about what you value, what you want more of from this life, and what you want to do in the next year. The more details you gave, the more personal the Sak Yant would be. The Ajarn listened deeply and tried to understand the powers you needed. He even spoke about the Buddhist ways of life, living simply, loving deeply, doing no harm, and setting some examples. I won't share more details on my conversation, as I do think it was sacred.

After our conversation, the Ajarn drew out what he thought the blessing should be for me to wear on my body based on what he heard. He showed it to me—explained each part of it, and then asked me where I wanted it. There are some placement restrictions, as it is a sacred tattoo, though this wasn't a problem for me. I chose my back, and he started tattooing.

The art of the Sak Yant is now done with a metal rod-like tool—previously, it was done with a bamboo stick, taking ink and poking it into the skin like a stick-and-poke method. My tattoo was done very quickly—maybe ten minutes, and it was not as painful as the many others I had gotten before this one. The Ajarn then blessed the tattoo, giving it its "magical powers." It is not my prettiest tattoo, but it may be the one with the most powerful meaning.

There are a set of rules to follow after receiving a Sak Yant to continue receiving its blessings. The rules are slightly different depending on your encounter as they are written by the Ajarn you get your tattoo created by. Mine included: don't cheat, don't lie, don't steal, don't disrespect your elders, and don't spit into a toilet. It is believed that if you do one of the don'ts, the tattoo will lose its power and no longer protect you.

The power of my tattoo stays with me through the spiritual connection I hold from the experience and my beliefs and ways of connecting myself to the Buddhist way.

~

I have been lucky enough to travel throughout my life. I've been to many places but also have many on my bucket list. Another thing that came out of this trip for me was affirmation. My partner and I explored the world again in a beautiful way—he joined me on my journey selflessly. He put himself in situations and participated in experiences he wouldn't have chosen for himself. He was with me for an incredibly spiritual tattoo experience. He made me feel seen and unjudged in a way few people have shown me.

On the plane home, I reflected on how magical the trip was and how much the man next to me truly loved me. I felt more connected to him and our relationship than ever and was happy to jump into the next decade of my life with him by my side.

That said, I did a "don't" about a year after getting my Sak Yant. You guessed it; I spit into a toilet.

CHAPTER TWENTY-THREE
THE TREE

After Russell and I got engaged, I asked Tracy (the friend I got the lotus flower tattoo with) to be a part of my wedding in a more significant way than just a guest. I wanted her to be a part of celebrating the next phase of my life. It was wrong to do this for many reasons in the end, but what I was slightly aware of when I asked was that I was doing it for the wrong reasons. I was doing it because of what our friendship had been years earlier and not for what it was at that time in my life. Nevertheless, I knew it would mean a lot to her to include her, and I hoped the relationship wasn't as off as I thought it was.

It's hard to tell just how off things are when you live in a different state. I had trouble understanding how to be in our friendship—as we didn't see each other often, and there always seemed to be some drama whenever we did. I didn't like how she prioritized or valued things when we were together. We both had grown in different ways, and I became someone I am proud to be (through a lot of growth and work). For several years, I questioned my voice, and Tracy stepped up for me and helped me own my space, but once I had achieved that, it became hard to own my space with Tracy. Ironic, right?

Tracy came into town with two of my other closest friends to go dress shopping and wine tasting. I was so excited—they were planning everything, and all I had to do was look forward to celebrating with my people. Russell was home and invited to some activities; otherwise, it would be just the girls.

Things started okay—but quickly became rocky. I won't go into great detail about what happened that weekend because they do not explicitly relate to the reason for my tree tattoo. But, by the end of the weekend, many of my core values had been stepped on, things were said, and people were mistreated in ways that, for me, meant that my relationship with Tracy had run its course.

Some of my values that were stepped on:

1. Quality time—this weekend had the potential to be filled with quality time for me and my favorite people to bond together as a unit. Instead, it was constantly being pulled apart to address Tracy's needs.

2. Listening and curiosity—there was a lot of talking, but very little listening and curiosity. These two leadership skills would have helped me to feel seen and heard for where I stood on matters instead of Tracy taking a stance for me based on the very little information she had.

3. Feeling seen and heard—there was no space for anyone to have a different opinion or share their truth anytime throughout the weekend. Instead, the interactions were brief, as it was hard to feel safe to be vulnerable.

4. Treating all people with respect and kindness— there were several occasions where people who were serving us or helping us with dress shopping were treated poorly and made extremely uncomfortable. Having worked in the services industry, this crushed my soul, along with my values of respect and kindness.

5. Irreparable Damage: Using assumptions,

manipulation, and projection to attack those I love— there were words that Tracy used that should never be said out loud to anyone, let alone the people I love. There was no space to protect or get control of the chaos and feel safe for everyone there at the same time. It was one of the hardest weekends of my life, as it jeopardized my most important relationships without cause. Witnessing the use of tools to try and control the situation, including people's feelings, was a major wake up call for me. It made it clear to me that I needed to take even more ownership of who I am and the type of people I want to surround myself with.

6. Leaving nature or places better than how you found them—our impact on this world and nature is one of the most important things to me. Nature is something to enjoy as it is beautiful, not something to destroy, so only you can take in its beauty. Many flowers and plants were smashed to fulfill a vision in a moment.

Nothing can be done today that makes any of what went on that weekend okay. The only thing I can do for myself is to learn and grow through it.

I care deeply about remaining humble and open in all situations and around all people. For this reason and others, it's been tough to let go of relationships that were significant to me at one time. But it is harder, and more damaging, to hang onto relationships with people who don't share my values.

My training with the Co-Active Training Institute has taught me that a good leader strives to balance living life in full self-expression and being responsible for their impact on others, and this is what I strive for as I continue on my path in life.

∽

We all know the saying, when life gives you lemons, make lemonade.

When I think about this saying, it represents turning something meh into something good or opportunity through optimism.

During my childhood, my family did a lot of fundraising for diabetes. We wanted to help advance the research to help Michael and do some good in the world. Michael loved planes and flying. All the gizmos and gadgets in the cockpit fascinated him. Besides being very young, the only thing stopping him from his dream of becoming a pilot was that he had type 1 diabetes. Pilots cannot be insulin dependent, which means Michael will never fly a plane unless there is progress in medical research or a change in the rules for pilots.

We made shirts that said, "Flying with Michael" and wore them when we walked or raised money for the cause. We even set up a lemonade stand and sold lemonade to each passerby, asking for whatever they could give towards the cause. The donation to beat was over a thousand dollars for one cup of lemonade. Our family at that time raised thousands each year to go towards Diabetes research—we were trying to stay optimistic about Michael one day being able to fly a plane—if he still wanted to, of course.

～

We went to the Botanical Gardens when Russell and I were in Singapore. Not only are these gardens and their flora just stunning, but they also highlight education about climate change and human impact.

One of the most memorable moments was when Russell and I stumbled upon a virtual reality (VR) project called Tree. Through VR, we got to experience becoming a tree in the rainforest. Our arms were its limbs, and we felt things from wind to rain to animals landing on us. We went from a seed looking up and out of the dirt to a small budding, all the way to a tall tree overlooking the forest.

Stop reading here if you want to experience this yourself and look up Tree by the Rainforest Alliance to find where this is possible in the world.

At the end of the VR experience, you witness trees getting cut down by humans and see the aftermath of the forest changing because

of human impact. Then you see a fire spreading—taking down your neighbors and finally burning you to the ground. You feel the heat as you burn.

I took the VR mask off in tears, looking for Russell and meeting his eyes, in shock at the damage I witnessed through the experience of being a tree. Knowing that the world was ugly in this way and how we have treated the rainforest is very much like that. Our impact on climate change and on the trees that are on this planet is something each of us must take responsibility for. They then handed us a seed to plant a tree and sent us on our way.

Russell and I left the Botanical Gardens, still in shock. I still tear up thinking about it. I wish there were VR experiences for all the terrible things that happen in this world. I think people would learn a lot from this kind of experience, and others like it, feeling it and witnessing it on a deeper level than hearing people speak about it.

≈

Have you ever heard a story that sticks with you? One that stands out to me is this acorn story I once heard during a call. I have tried to find it online but have not been able to, so I'm not sure who to give credit to for the story.

A group of acorns had fallen from a tree—they all felt free! One acorn in the middle of the group sat staring up at the sky and the tree the group had fallen from. The acorns around were all shining themselves and relaxing in the sun.

Another acorn came up and asked that one acorn, "Hey, why aren't you shining yourself? You kinda look like you need it."

The first acorn said, "My goal in this life is not to be a shiny acorn."

The second acorn said, "What else would you be?"

The first acorn said, "I want to be that oak tree, with all the knots and bumps and all."

This story reminds me that I can choose who I am and who I want to become. I am the author of my story. The captain of my ship. The leader of my life.

I looked at my lotus flower tattoo on my ankle and wanted to grow it into something more. Thinking hard about the type of person I was in that moment versus the person I was before, I decided I wanted to be a tall pine tree instead of a lotus flower. I wanted to carry the muck of the water with me—not waking up without a trace each day, but rather celebrating the stuff I had been through and grown through.

Some say pine trees symbolize the triumph of life over darkness. Some say pine trees represent fertility, wisdom, and longevity. To me, it is all of these things and many more—it is my growth tattoo and a reminder that I am human. It is my only coverup.

CHAPTER TWENTY-FOUR
THE SMOKE

Smoke, to me, means the transition over time of mind and spirit. I am a lifelong learner, so smoke reminds me that growing and developing into a great leader is me being on track, aiming at my goals, and learning through failure.

When my cousin Amanda and I got our arrow tattoos, our relationship was in a different place than it is today. As we got older, our relationship became even more strained. There were times I went to visit her when I was incredibly uncomfortable because of the positions she put me in or actions she asked me to take that didn't align with my values. There were even times when I felt physically unsafe and wanted to sink through the floor and disappear. I am not proud of who I was in those situations then, and they were pretty scarring for me and my relationship with my cousin.

In most relationships, a lot of growth and change happens over time. In this relationship and others, I have had to learn to set boundaries to protect myself and the things I stand for. This has been both wholly heartbreaking and challenging from every angle with Amanda. My priorities and values no longer felt held within the relationship. As a

result, I didn't get the same things from the relationship that I once did, and I often left a conversation or meeting feeling more drained than when I entered it.

I have fought with myself through each phase, wanting to be enough of a person/leader to have a healthy relationship with her while holding myself fully. I have spent many hours being hard on myself, feeling like I have failed her and myself. Yet, I kept trying to extend myself further to show her the unconditional love that I know to be true.

With Amanda, I hope for only the best for her in life. At the end of the day—the kind of love she wanted from me is more of an accepting love, a joining her where she is love. She wants me to participate in her life in a way that does not hold judgment or hesitation. While this is a beautiful love that many of us yearn for, it also misses the other side of love—the more guiding side where people can tell you when you seem off course or stand up and say no. It misses the kind of love where you are not made to be wrong for saying no or choosing to not participate in something that makes you feel uncomfortable.

Love to me is not just a noun but a verb, and sometimes, loving someone is trying to remind them to love themselves and that they don't have to do or be anything they don't want to be. And sometimes, the act of love is to let go. Be happy for them and their successes from a distance. Loving ourselves is one of life's more difficult journeys. Standing up for your values and honoring them can be very taxing. Love should not require you to do or be okay with things that go against your values ... ever.

There are complex relationships that everyone will face throughout life—and sometimes, choosing you can be the hardest decision to make. If someone doesn't want both sides of love—you cannot force it upon them. All you can do is stay conscious of your values and be true to yourself. Be an example of the leader you want to be led by in each moment. Finding balance in meeting people where they are and showing up fully as who you are.

Amanda and I don't have much of a relationship these days, but she will always hold a special part of me, and I will always love her and wish the best for her. Our paths have diverged, and our love for each other

is not what it once was, just as we are not who we once were. My arrow will always be about the connection you can have with someone—and I will forever be grateful for ours when we were young.

∾

Our arrow still represents a meaningful relationship to me today. It was one of my closest relationships when I was young, and Amanda was there for me through many significant moments. It means something slightly different to me now than when we first got it. It still represents getting somewhere and aiming at the right target, but it is more about ultimately remembering where I came from and what I care about, finding the guiding piece within myself and those that love me. It is easy to get distracted in this life, and my arrow is a good reminder of my core values and staying true to myself and who I am as the leader of my life.

∾

I wanted to add some pizzazz to my arrow that both made it mine and showed my growth and development. So, I asked an artist that I really like to add smoke to my arrow—I showed him a couple of examples, and he made something beautiful happen. It was a perfect addition to my arrow because it symbolizes my growth over the years and the power I have within myself to guide me through life, the unknown and the known! It is also simply beautiful and means even more to me than it did before.

CHAPTER TWENTY-FIVE
THE HOT-AIR BALLOON

There are two things that I am afraid of in life. The first is sharks; I don't know why, but they scare the shit out of me. The second is what people are capable of. I mean, seriously, though, people are terrifying. As a yes person to all things travel-related and a thrill seeker, these two fears can throw a wrench sometimes.

When I was a teenager, my dad was asked to give several talks at a conference in Cairns, Australia. He told Michael and me that this would be an excellent opportunity to scuba dive at the Great Barrier Reef. Which, of course, was something we both wanted to do badly, so we started scuba lessons.

Our lessons in Utah were in a deep pool with fish, sharks, and even an underwater structure to explore. They were nurse sharks, which are known to be docile. However, that did not make me feel better as we entered the water.

The water had very low visibility—they wanted you to learn in poor conditions so you could navigate the open water. Barely being able to see a couple of feet in front of you makes things even more stressful if you are afraid of sharks and you know they are in the water with you.

One day, we went to the bottom of the pool, following a rope down. We were then to move to the sunken structure as a group and use the hand signals we learned to explore the wreck together.

The instructor went down first, and I followed. The five others in our group were supposed to follow after me. Once the instructor and I reached the bottom, we waited a minute, but the others didn't join us. The instructor gave me the "stay here" signal and went to find the rest of the group.

I sat by myself at the bottom of the pool for several minutes, simply trying not to panic, which is a significant part of scuba diving— breathing normally and not doing too much. I was trying to see through the dirty water—every once in a while, thinking something was coming towards me—and looking up often to see if the others were coming.

Thinking about returning to find everyone, I closed my eyes and breathed, slowing in and out, focusing only on my breath. When I opened my eyes, a nurse shark was swimming by me, immediately followed by a black fin that was the instructor's foot, almost hitting my face.

I knew I was safe the whole time in my brain, but in my body, I thought—this is the end. You will get attacked by a nurse shark in a pool in the middle of nowhere. You will not make it to the open ocean, and you will die here today.

The instructor made eye contact with me and asked if I was ok with hand signals, and I signaled back that I was and made it through the rest of the lesson. Part of me was working past my fear, and part of me was just angry that he left me alone for that long.

A few months later, we were at the Great Barrier Reef. One rule when scuba diving is to always dive with a partner. If your partner has an issue, you have an issue, and vice versa. Michael and I were ready to take on the adventure together.

Michael jumped into the water first, knowing me and my fears. I jumped in, following him, and started making my way down. As soon as we were underwater, I looked around and saw three reef sharks, all swimming within eyesight. I stopped breathing, widened my eyes, and felt Michael's hand on my ankle. He pulled me to his level and made eye

contact that said, *We are fucking doing this, Sami. Breathe.* He sat there staring at me until I breathed like normal, and we took off exploring together.

It is another world underwater. The calmer you can be, the more you can see. Fish, reefs, sharks, and more all live in the same waters. Some fear each other, just like on the streets of a large city.

It was an incredible experience, and I was proud to have pushed through my fear and been able to be present through the adventure. We saw so many cool things, but I did opt out of the night shark feed dive, deciding that was a step too far.

~

A couple of years after our scuba diving experience, I made my way to Tikal, Guatemala, for an overnight weekend getaway from my internship in Guatemala City. Still being a thrill seeker after a full day of exploring the jungle and several pyramids—the group of interns and volunteers I was with did an eight-hour tour with a guide that took us on an extra-long walking tour of the jungle. It exhausted us by the end of the day.

We stayed in the national park hotel for the one night we were there. There was a restaurant/bar on site that was the spot to eat available to all. Our group went there and sat around a table, drinking beers and eating food. Our tour guide sat at the bar doing the same. Eventually, our group and the guide started chatting again, and he sat with us for a while, telling stories of the jungle. We all got a bit tipsy and decided to go on a short walk through the jungle, looking for jaguars. In hindsight, and even in the moment—this felt like a bad idea, but the guide was compelling, so off we went.

We walked into the jungle on one of the paths away from the hotel. We made it probably a quarter of a mile before you could only hear the jungle around you, and things got intensely scary. Our guide told us at the bar that a jaguar was nearby if you could smell cat pee. At the bar, this was a funny and interesting fact. We kept smelling the air in the jungle, hoping we would not smell cat pee. Wanting to stop walking

into the wilderness but also totally unwilling to get separated from our guide, who continued walking with passion, our group stayed close like people do when they go through a haunted house.

Suddenly, the guide stopped walking. Fist in the air, our guide spun around with his finger to his lips. We all stopped walking and held our breaths for as long as we could. We smelled cat pee in the air as we breathed in once more—a wild boar running across the path in front of the guide. Then, we turned onto a different path, leading to a small body of water. The guide pointed into the distance in the water— holding a flashlight on two eyes - a crocodile's eyes. We all stared at the guide and each other, terrified. We motioned to the guide that we had had enough and wanted to return to the hotel, afraid to speak out loud.

He chuckled and said—yes, let's; it is not safe here. He turned us around and led us back out of the jungle. Feeling the eyes of the crocodile follow us for much longer than I would like. Making it out safe and feeling like we had just survived something crazy, we headed to the hotel pool for a night swim. We talked about what we had just experienced and how scared we were. The pool was outside and not lit up—you could see so many beautiful stars. It was magnificent.

Calming down, we all lay in the water looking up into the night sky when there was a splashing sound from the pool's far end. We all looked at each other—trying to figure out who made the splash; it happened again—starting to freak out as it was not any of us making the sound. Someone jumped out of the pool and grabbed a flashlight, shining it on the far end. To our horror and relief, large bats flew to the pool to get water, making a splashing sound and flying back up just over our heads.

Happy that it wasn't a crocodile or a snake. We left the pool and went to bed, calling it a day after many scary moments. I do not recommend walking in the jungle at night in this way—though it was quite the thrill-seeking adventure—if something had gone only slightly wrong, it would have been horrible.

～

When I was seventeen, my friend and I decided to go skydiving. Being under eighteen meant I had to get some paperwork signed by my father. Knowing that he may or may not sign off on this experience, I planned to ask him when a lot was happening. I walked into his office, seeing him deep in thought, tongue out of his mouth in complete focus. This was dad's focus/busy tell. I approached his desk.

I told him I wanted to go skydiving and needed him to sign my permission form. He said mm-hmm, and signed the paper as I held it up to him, barely noticing me or anything else. I ran out of the room, called my friend, and said, "I'm in!"

My friend's mom took us to the facility they had found that was supposed to be the safest experience near us. We did the training and set off to jump out of a plane!

As I leaped from the plane, I had no fear and was totally ready to experience the free fall and see the ground straight below me. It was very exhilarating and scary only for a few seconds—when I was about to pull the chute and thought briefly—*man, I hope this thing works.*

The free fall was amazing and went by in the blink of an eye. The wind during the free fall pulled my skin tight, making my face feel crazy, almost distractingly so—then I pulled down on the chute and held my breath to find out my fate.

The likelihood of the chute not working, especially in this setting, is incredibly low. That doesn't mean you don't have that moment of fear, though. I imagine it happens every time, even if it's just for a split second. Having gone skydiving more than once now—it has for me.

∼

When I lived in Texas, I decided to experience airborne travel in its earliest form—by balloon. I found a hot-air balloon ride experience online and booked it. I got a couple of friends to sign up with me, and off we went.

We got there very early to catch the sunrise as we took flight. This adventure was post-skydiving and scuba diving, so I wasn't expecting much of an adrenaline rush, but I was hoping for one. We piled into

the basket, and off we went.

Now, a couple of things surprised me from this experience. The first surprise was how difficult it was to get into the basket. In the movies, people hop in quickly; this was not my experience. It was hard even for the fittest of people. The basket was tall and moved around as you tried to climb it, and it required a lot of core engagement to get into the basket.

The second surprise is obvious in hindsight, but it was hot! Like, very hot. I don't do heat well in general, so maybe it was worse for me, but man, it was hot. The kicker is that you can't get away from the center of the balloon unless you were to get out of the basket. Yes, I thought about it several times throughout our trip.

The rest of the experience was quite lovely. It was a very peaceful experience (not full of adrenaline for me). We floated for a while and watched the sunrise. We were sipping coffee and chatting about life. I highly recommend it at some point in your life. Maybe not in Texas or anywhere else that is also hot, though—you can only take so many clothes off.

~

I spent several mornings in a row at a hotel in Calistoga, CA, where I was up early, and the others I was with were sleeping. I sat outside because, as usual, California's weather was amazing, and I watched hot air balloons flying over the vineyard surrounding our hotel. It was simply gorgeous. I sipped my coffee and thought about life, who was present that I was extraordinarily grateful for, and my dreams and goals.

I reflected on the relationships that no longer served me—whether we had fallen apart or drifted. I have many people that meant quite a lot to me during specific periods of life that I no longer talk to for some reason or another. I believe that many relationships have a natural arc to them and that as we grow, move, and age, we often see the people who we spend the most time with shift as well.

I also have many friends I still stay in touch with and care deeply about. There are friends I have known for years where no matter how

much time passes between connection points, the relationship and conversations are as deep as ever. There are also friends I communicate with weekly, keeping them up to date/me up to date as things happen in life. I have been fortunate in the friend department, especially having lived in many places. It feels like there is always someone nearby that I know and love, no matter what city I'm in at the time, and there is always someone I can count on to answer the phone, no matter what time it is.

Hot air balloons remind me of drifting relationships, traveling to those you love, and thrill-seeking. Because of these reasons, I added a small hot-air balloon to my wanderlust tattoo, again making it mine and letting go of the relationship I once had with Ashley (the friend I got the wanderlust tattoo with). I was giving myself grace in my relationship successes and failures and trusting my gut to let go or hold on when I should—growing into my leadership and being myself in my full expression. Taking on adventures headfirst and letting go of things and people that don't add to my life.

Begin again

CHAPTER TWENTY-SIX
THE BEGIN AGAIN

Beginning again isn't just about starting over; it is about moving through life, learning, and growing. It is about owning ourselves and our flaws as well as our strengths. It is about leading with our whole selves and making the impact we want to make on this world.

~

My dad became frustrated with my exam scores when I was a teen. I always got straight A's on all class assignments but did worse on tests regardless of the subject. I didn't like how they worded questions and had trouble thinking through things in the way they wrote exams. So, one day, my dad connected me with a specialist to determine if I had any learning delays or issues.

I took a series of developmental tests to see if and where I did not meet the marks of my age group. I passed these tests, and the specialist gave a report to my dad with the suggestion that I was human and was not interested in the subject being studied. This process was interesting for me as I both felt incredibly stupid and frustrated because I was trying

to pass the school tests with higher marks, but found them challenging. My exam struggles did not end there.

~

My dad enrolled me with a tutor early in high school to prepare me to take the ACT and SAT. Both tests would help me get into the top schools across the country, each requiring one or the other. Not knowing where I would end up yet, but knowing it would be out of state, we decided I should take both.

With the SAT, some schools took your highest score from each section no matter how many times you took it. With my test-taking skills not being the best, I planned on taking full advantage of this. Each time I took it, I did better in a particular section, just as expected, and I could turn in my highest scores to several universities, increasing my chances of getting in.

Years later, after graduating from nursing school and studying for months, I signed up to take my NCLEX, the last test to become an officially licensed registered nurse. Having had a very negative relationship with standardized testing, I was terrified. It felt like my entire career was on the line. It was me versus this test; it was all I could think about.

The NCLEX comprised between 75-265 questions. The test ended when the computer decided whether your performance was above or below the passing line. The longer the computer couldn't determine if you had passed or failed the more questions you received, up to 265. Going into it, you never know how many questions you would receive, and you would not be able to tell how well you were doing.

The cherry on top—each question has more than one correct answer. You are supposed to assess them all and choose the best answer to the question. There are also many multiple-choice questions or order questions.

The NCLEX was very hard for me. In clinical practice, you do more than one thing at once frequently, and there is often more than one person in the room, especially in high-stress moments.

Airway, breathing, and circulation are the top three priorities (in that order) to make sure a patient is stable. With more than one correct answer, choosing the best answer was stressful, and the situations (in the questions) were complicated and difficult for me to relate to direct patient care in real life.

I failed the test. Over and over. I found it impossible to think the way they wanted me to when taking the exam. What made it feel even worse was that I usually received the full 265 questions, meaning I was going just below the passing line and then just above over and over again. This was very hard for me to accept. I had never received a grade lower than A in any of my hands-on classes, and I knew I was good at my nursing skills.

My body attacked me as I went in to take the exam, each time getting worse. First, it was simply nausea; then, it was throwing up before entering the building. Finally, it was getting spots in my eyes as I walked into the testing center.

I thought it was anxiety that I could overcome through therapy and other self-work, but it was more than that. My body told me it didn't want to keep fighting for something I didn't love. A career in nursing for me would mean only being able to help people in the immediate and short term for the units that I was interested in. I loved the emergency department and could not see myself working on the floor anywhere else. Yet it wasn't fulfilling.

Some people I've spoken with about living a fulfilled life argue that most people are not fulfilled by their job but instead by what they do outside of work. While I am also living life to the fullest outside of work—I wanted the thing I spent most of my time doing to be something that left me feeling like I had made a difference long and short term. I wanted to help people more profoundly than I found I was able to as a floor nurse, and I wanted to make a more significant impact.

I did not know what this meant, and it took my dad's colleague to tell me I did not need to be a floor nurse before considering a different path for myself. My dad had asked her to go to lunch with me and talk me out of my feelings and into pursuing a nursing position with a

better attitude.

She instead listened to me and what I wanted from my career and said, "Sami, you sound as burnt out as I felt after I worked as a floor nurse for twenty years There are other careers you can do with a nursing degree. Let's figure out what you want and not keep you in this box." The lunch did not go as my father expected, but I was able to set myself free after that.

I've gone on to do bigger and better things, still in healthcare, working on improving the quality of patient care for women and children. I also work on improving self and team connections through leadership workshops and emerging leader coaching. I love what I do now and would never have gotten to this place had I not struggled through it.

<p style="text-align:center">∼</p>

When I first got my coaching certification, I again found myself up against a final exam. It was an oral test that was pass or fail, and it was the only thing between me and becoming a certified coach. I loved coaching and knew this was an important test for me. But, once again, I was terrified of what it would take to pass this test with my test anxiety and history of struggling with exams.

I went into this test nervously, which showed on my first exam. I knew before they told me I had failed and would need to try again. I spent time between tests, working on some of my test anxiety and trusting myself more. The second time I took it, I was stronger, but still showed some nervousness. I failed again.

I signed up to take the test once more and asked some fellow coaches for help. We practiced the exam structure once a week for months, doing precisely what they would ask of me on the exam, followed by a brief feedback session to help grow me as a coach. We did this so often that I no longer went into the exam second-guessing myself. This added to my work to reduce my test anxiety—I felt confident and leaned into myself and what I knew.

Taking the test for the third time—I finally passed! The test ended,

and I felt proud of my performance. I had finally laid it all on the table and been my badass, coaching self.

~

Many examples of beginning again throughout my life have been significant moments of clarity followed by a considerable shift for me growth-wise. Some of these include:

• After I had failed to train enough to get a fast time running a mile, and didn't make the varsity soccer team during high school.
 o Begin again—I trained hard and became the captain of the junior varsity team and a leader/advocate for our team.

• After I got several speeding tickets, lost my driver's license, and had many hours of community service to serve.
 o Begin again—I was able to do community service hours volunteering in the emergency department and on ambulance ride-a-longs. Helping people and showing myself that life was worth living and driving dangerously wasn't worth it.

• After I struggled to communicate how I felt and what I cared about (over and over again) with my now husband and we broke up.
 o Begin again—We tried again to communicate our feelings to one another. We shared our deep truths, allowing space to reconnect stronger than before after time apart to heal and get clear on our emotions and what we wanted.

• After I gained weight because I stopped trying to eat healthy for the umpteenth time.
 o Begin again—Choosing my health and longevity of life,

I worked hard to lose weight again.

There are also examples where I continue to begin again often. They are growth opportunities over and over again. Some of these include:

- Every time I notice my impact does not align with others' perceptions of my words or action.
 o Begin again—Owning my impact through articulating what I'm noticing versus what I meant and leading through it.

- With every failure I go through to achieve any goal I have.
 o Begin again—taking the time to learn through failure, growing stronger because of it, and choosing to have it help guide me to my future successes.

This is why I have "begin again" tattooed on the arch of my foot. It reminds me of my commitment to myself to take one step forward after self-reflection and correction in whatever form necessary to achieve my goals and be the strong leader I know I am.

CHAPTER TWENTY-SEVEN
THE HORIZON

I am like the horizon—capable, strong, calm in a storm, earnest, passionate, wise, intense, bold, weird, edgy, and deep. I am reliable. I am many things, some of which have taken me many years to accept about myself.

When I was twenty-eight, I took leadership training offered by The Co-active Training Institute (CTI, the same organization where I did my coach training). It was a program that my best friend had done and loved, and it excited me to learn and grow my leadership through the program!

Through the program, they teach major leadership skills through experiential training. The program is excellent, challenging, and impactful. There is a part of the program where a group of almost strangers shares what your impact has been and how they perceive you, which is something many leadership programs include. CTI's program includes this and much more learning—it was the first example of this kind of leadership development experience that I had participated in as a learner/grower.

One of the most important things I learned during this time was

how people could see through my barriers and efforts to be and act like others. They saw me at my core more than I knew and could tell when I was myself or if I was trying to perform in a certain way. The program and the people involved helped me set myself free to lean into who I am and not what I think others expect me to be. Yes, I was already a grown adult at this point. Still, I have always had high expectations of myself and had a difficult time staying with myself in my leadership instead of trying to do things the way others I looked up to did.

It turns out that I am someone others naturally see as intense, bold, capable, passionate, and more. There was a part of me trying to hide some of these traits from others, as I thought it made people more comfortable when around me. Living as authentically as possible brings more people in—the only caveat is that it requires being more vulnerable. It is easier to fail if you are not living your leadership/ life in full self-expression. It can hurt more when you fully express yourself but struggle to connect with others. Still, you likely would have been unhappy doing or having a relationship with those that don't understand you, anyway!

As I've learned to live into being a strong leader as myself (not trying to be anyone else) through CTI's program, my goal is to live life fully expressing myself while being responsible for my impact. I will continue to learn and grow while holding this moving forward, but I am so excited about the journey ahead and happy to be able to take it on confidently as Sami.

~

Our family went to a friend's cabin on Thanksgiving when I was around eight or nine years old. Getting there in the late fall/winter months involved getting through a lot of snow. We had to park our car far from the cabin and then snowmobile in because the snow was so deep. This was a blast for Michael and me, as we were excited to be in deep snow. We were thinking, of course, of all the crazy forts to be built!

As soon as we reached the cabin, we suited up with the other kids to build a fort. All of us were in head-to-toe snow gear, shovels in hand,

and smiles on our faces as we started to build. We wanted to create a cave-like structure where we could all fit comfortably, like an igloo meets a cave in the deep snow. Our parents wanted to go snowshoeing, so they left us at our fort building to watch after one another. They would be close by (within earshot) if we needed anything.

We had built the main room of our structure and had a tunnel in and a tunnel out—Michael, the smallest, was the first to try to fit throughout the tunnel out. He made it out to the other side and found that where he was standing was slick. His reaction was to skate around because it was fun.

The older kids and I watched him for a minute and realized that he must be on the water that iced over. We started yelling at him to come back towards the fort. As he turned to do so, the ice cracked under his feet, and he fell through, vanishing from sight.

We all started screaming (getting our parents' attention)—and in fast action, we decided as a group to make a chain; I was going to go out to the spot he fell through, but we wanted to be able to pull me back if need be. So, we made a human chain, with me slipping my way to where Michael disappeared. My mom (being incredibly fit) was running back on snowshoes, and we could see her running back to us in the distance.

I got to the hole (this was all within probably sixty seconds of him falling through the ice) and saw the cord of his glove stuck on one edge of the hole. Reaching for it, I realized his hand was still in the glove! I grabbed his arm and pulled him out—our human chain pulling all of us back to safety. Michael was breathing but not speaking, almost blue, shaking from the ice-cold water.

Not knowing what to do—we all took off our snow gear and wrapped it around him, trying to make him warmer. Within another minute or so, my mom reached us and took charge.

We got him into the house and warm again, thankful that the situation was not worse. What had happened shocked us and we were scared to build forts again for the rest of the day, opting to play games inside instead.

One of the many things I remember vividly of this event was the calm I felt in the storm. My natural state is to remain calm and take

quick action, and I did not panic and break down until Michael was inside and under our mom's care. I didn't hesitate; there was only direct communication and calm in all the panic. It's like everything around me gets quieter, and my focus is clear. I can hear both my heartbeat and the essential things that others say at the same time.

That day was the first time that I remember feeling that feeling vividly. It turns out that feeling is still one of my superpowers, and I've used it many times to help navigate emergencies, stress, and high-emotion situations.

~

Throughout my life, I've never felt like I think how others think. People always seemed fascinated by my train of thought and confused by how many perspectives I could hold at once. This was my natural state and is both my superpower and my weakness. I am a verbal processor in a way that can be uncomfortable for others and myself sometimes. I have to talk through many perspectives before I land on how I feel about the choice. Often, I end up confusing the other person during my process as I sound like I mean each point I make, and I stand behind each of my perspectives as I talk them through. Sometimes I feel more than one tremendously, but usually, I can land on one that is the core of "my onion" after exploring all perspectives out loud (my loving husband calls my process an onion, peeling back a layer at a time).

It can be hard to think through situations where I empathize with more than one perspective. Sometimes it's hard to take a stand for what I believe in, even though I have strong opinions. In all situations, there needs to be equality and respect shown between all parties. There are times when you might be standing on opposite sides of an argument, but if you take a moment to try on the other person's perspective, you will only learn and grow from it. There is always a third way or another option to take together, and it starts with agreeing to disagree.

While I don't always get there quickly—at the end of the day, what I care about most is all parties involved enjoying themselves. We all have different priorities and things that we care about, making us both

individual and human. Knowing when to succeed versus fighting for something is half the battle in life. Standing up for what you believe in through being who you are at your core, without hesitation or pause—following your life's purpose and leading your life in full expression with responsibility for your impact.

While the symbol of the horizon came to me through the CTI leadership program, it also continues to be a way for me to center myself in times of need. It reminds me not to take things so seriously and live every day to the fullest.

This is why I have a horizon tattoo on my shoulder blade. It is a simple circle and line without color. I am the color of the horizon. I am the beginning and end of my days. I am living life to the best of my ability and consistently trying to impact those I encounter positively.

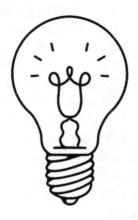

CHAPTER TWENTY-EIGHT
THE LIGHT BULB

When I was a teenager, I went to Sydney, Australia, with my dad and brother. While there, we made a trip to Manly Beach. Michael and I, strong swimmers and very athletic, immediately wanted to take surfing lessons. My dad, being supportive of anything exercise related, agreed.

Many surf schools on the beach were ready to take anyone out into the water. The waves were cresting, and the water was warm—we were ready. Out we went, excited and hopeful to catch a wave and look like rock stars surfing our way back to shore.

It took a very long time to stand up on the board after catching a wave. The first wave I caught, I was too far up on the board and did an accidental nosedive into the ocean. The wave's motion caught the board as I was still underwater from my fall, and it was strapped to my ankle—this was not a fun experience. Underwater and upside down, being thrown by the current, coming close to hitting myself on rocks, and running out of air. Finally gaining control and coming up for air after just being thrashed, I had a moment where I thought about giving up—heading back to shore and laying on the beach instead of trying to master surfing.

My lungs and body were exhausted, but my gut and pride told me—*nope, get back out there. Get back on the horse, Sami. You know you have more gas in your tank if you set your mind to it.* So out I went. One last time. Ready and determined to get it right this time.

Again, it took many minutes to catch a wave. Once I did, I jumped onto the board and didn't nosedive! With no plan, I rode the wave to shore—not needing to worry about it crashing on me (it wasn't that large of a wave this time). I rode it and waved to my dad. Proud of myself and still exhausted. Jumping off the board into the sand and running up to my dad like a rock star. Asking him, "Did you see that?" and him saying, "Yes, you got up!"

I stuck my board into the sand like I saw people do in the movies and sat and watched Michael continue to try to surf. I was feeling good about myself and strong, both mentally and physically. Proud that I didn't give up and that I trusted myself to learn through my failure.

That's how I feel about my goals and dreams. There are many failures we must go through before we succeed at things. We have many ideas that are "lightbulb moments" where we need to lean in to create magic, trusting ourselves and our ideas.

∼

I have always been a people gatherer. I love all types of people and am drawn to good humans, no matter their interests or what clique they belong to. During business school, I had an idea to start a coworking space. I wanted to have my own business, and coworking was about gathering people. It was also something I could do while I continued to work since I could utilize the space.

I was excited and motivated. I found a space I loved—it was perfect. It was on the main strip of a cute neighborhood, and there was nothing like a coworking space nearby. I partnered with a close friend who is an architect and drew up some plans to turn the space into a fantastic coworking venue. We did our best to create a market analysis and did all kinds of equations and project management to see how long it would take to start making money. It would be called Work Local—we even

had a logo and a website!

There was only one problem—the numbers didn't work out with the high rent cost. So, we came up with a plan.

We knew that gyms and even restaurants often get percentage-based leases because their design is limited by headcount and turning machines/tables. We thought that coworking should be in that same bucket. Unfortunately, it was a relatively new concept at the time, so there were few examples for us to pull from that had successfully negotiated these types of leases for their spaces. That wasn't going to stop us, though!

The real estate broker was difficult to work with as she was trying to balance working with/for the renters of the space and us. It was in her best interest if we paid the rent the way they designed it and not in any other fashion (like a percentage-based lease).

We told the broker we were almost positive we wanted the space and to set up a meeting with the owners who would rent it to us for one last conversation. In hindsight, she misunderstood this to mean that we would sign the contracts simultaneously if the meeting went well. Our plan felt shady to her, but she wouldn't pitch the type of lease we wanted to the owners, and it felt like the only way for us to present our ideas to them.

We came prepared and presented our designs and numbers—forecasting what they would make and when. We explained that the percentage-based lease would be better for them long-term. It went amazingly! They said they would have to think about it, but it seemed reasonable, and we left feeling on top of the world! Adrenaline pumping and excited to have our own business.

A few days later, the broker said it was looking like they would go for it—the owners liked us and believed in what we were going to build. We were ecstatic! But then, a few days after that, she called and told us they decided against a percentage-based lease after all. It was devastating.

To this day, I believe it was because the broker convinced them otherwise. It was clear that she would make significantly more money if it were the original lease plan, and she was not happy with us for trying

to pitch something else to the owners. She even wanted to loan us the cash she would make off the deal as an investment to get us to take on the high-rent version of the lease.

We declined and moved on from the space. Ultimately, it wasn't the right time, and we were better off throwing our energy into other things.

What I learned most from this was that my ideas were good. Even though we didn't get the space, our pitch night was terrific. It was so much fun to try to change people's minds and show them why our plan was worth it. I learned many other lessons during this effort.

In the end, I'm grateful it didn't take off since the COVID pandemic happened during what would have still been our lease, and I'm not sure we would have survived that time since coworking was not a thing people were doing as social distancing took over.

Everything happens for a reason, right?

~

After coworking, my entrepreneurial spirit led me to team leadership workshops. After my leadership program through The Co-Active Training Institute, I partnered with one of my peers I met through the program. We kicked off a workshop as part of the program's requirements and fell in love with leading leadership development with each other. We were both surprised at how much we enjoyed working together and all the positive feedback we received. People who attended that first workshop came together from all different backgrounds and industries. After the workshop, several asked us if we would do similar work with their team.

We said yes and built programs for each team—catering to what the team wanted to learn and making experiences to help them amplify what they could do together. We were still determining how it would go since we didn't live in the same state or even part of the country, but we quickly found that neither did many of the team members we would work with. It was a blast, and easier than expected to translate it to being hosted virtually!

Our work took off—we started mainly doing pro bono work as we built our brand and intellectual property. We did a ton of work in the first year and loved (almost) every minute. We continued working well together and having fun building the many workshops we were doing, so our company, 1TeamCatalyst, was born.

Our business continues to serve teams today, and I continue to be grateful for my business partner and the work we do with different groups. We've worked across several industries with groups small and large. We offer in-person workshops as well as virtual. We find that many teams benefit from a virtual environment because more of their team can participate, especially as many teams include people from many different locations. Every time we are facilitating a team it requires us to lean into what we know and what we see in the people and team dynamic. We are pushing boundaries and helping people grow and shape themselves as leaders—helping people and feeling entirely on purpose—leading life intentionally.

∼

I got a light bulb tattoo on my forearm to remind myself to trust myself and my ideas. It is the flashes of inspiration that remind me to take the jump. Try the hard thing. Learn from my experiences and failures. I have big dreams and goals, which will require me to lean into myself and the things I know for sure—this book is one of them.

I am not famous or someone others recognize on the street for any reason. I am a human who is driven and motivated to make a positive impact on the world. I want to leave the world in a better place than how it was before me.

I have seen death both of close family and loved ones and total strangers; I have lived life fully—I have jumped out of a plane, scuba-dived, seen famine, witnessed wrath, been raped, been broke, and been privileged. I have been anxious, drugged, an athlete, tried something new often, and taken enormous risks. I have fallen in a deep kind of love, done a fuck ton of therapy, and even made a family of my own. I have traveled the world, worked in the service industry, and have a

business I am proud of. I continue to grow every day, and if even just one person learns something from my experiences, that is good enough for me.

CHAPTER TWENTY-NINE
THE MOON

When Russell and I moved in together, we struggled to find a place we both liked. We were each bringing a dog, so we wanted a yard and a park nearby to make dog care easier. The places within our price range weren't super nice, and it took us a long time to find anything we would consider. In a last-ditch effort, we decided to look at a place on Craigslist listed as a mother-in-law unit. The pictures were lovely, and the home was in a great neighborhood. Feeling hopeful after being deflated, we decided to check it out.

As we drove up, we were in awe. All the houses in the neighborhood were stunning, there were parks nearby, and it seemed like a dog haven. As people passed us on the sidewalk, they greeted us kindly and wished us well. It didn't feel like any other experience we had had apartment searching. I knew I would fall in love with it as we entered the gate. As we rounded the corner into the backyard, my eyes widened, and I would have said yes, not even looking at the unit. The yard had a view of the stunning Olympic Mountains and the sound. It was a large grass yard, perfect for our dogs, and it felt private compared to many of the alternatives we had seen.

We toured the place in probably sixty seconds as it was perfect, and we knew it. We looked at each other and didn't even speak—agreeing this would be our home. We walked to the garage with the owners, chatting about the space and how the neighborhood was—all of us trying to feel each other out, did we like each other enough to be in the mother-in-law unit?

We stood in the garage and pitched to them that we wanted it—we had great jobs and were great tenants. We had two sweet dogs, and we absolutely loved the space.

Russell asked what it would take for us to stand out against other applicants. We left on a high—excited about what was next for us. We were not 100 percent sure they would accept us, but they told us they would let us know, pending our application later in the day.

We found out a few hours later that they accepted us; the rest is history. Our landlords became family; Ana, my soul sister, is one of them. We bonded immediately over wine and many long conversations. We were besties for life and knew this would change our lives forever.

The beauty of my relationship with Ana is that it is authentic. We can be ourselves with all our stretch marks and scars showing. We laugh with our bellies and cry with each other. We are stronger knowing the other is there, even when we aren't together physically. We are willing to take on more risks individually and together because we have the best kind of cheerleader—someone who knows us even in our darkest moments and still believes in us and what we want to accomplish. Our connection became deep quickly, and life wouldn't be complete without one another moving forward.

Ana and I are co-hosts through this life and have a blast doing it. The only thing we complain about to one another is how often we must share each other with the other people in our lives.

We love them all dearly, but it isn't the same as us, just being us.

We can do hard things—we know it in our bones and challenge each other to take it one step further than our comfort zone every time.

We push each other to grow while still being our fabulous selves, and we stay humble and vulnerable while we are at it. Ana has been my safety net, rock, matron of honor, and confidant. She married Russell and me—twice! She will be in our children's lives as an adult who loves them dearly and will continue to be my best friend through all our future adventures.

~

Ana and I have a deep connection—I can feel it when she is worried about something. When I can't sleep, she can't sleep. We check on each other when we feel we should, or when something has happened that we need to work through. We get each other in a rare way—in a way that feels more spiritual than like friendship at times.

As we are witchy and spiritual but not religious, the moon has been something that we have always loved. The moon alters moods, tides, and energy—a powerful symbol of power and beauty. The moon is one of the many ways we can connect to one another, no matter how far apart we are physically. Trusting that we are holding space for each other, no matter the need or what has happened. Our bond is always strong, always present, and authentic.

Ana and I got crescent moons on our forearms to symbolize this bond in white ink. A reminder of the power we have to access each other and the power we must use to shift our worlds. It is a symbol of our connection and love. It is my latest tattoo and likely my last for a while, as I have represented my allies (my leadership lessons and reminders to myself) well on my body to date. Proud of each of my pieces and content with where and who I am today.

CHAPTER THIRTY
THE UNKNOWN

Life's lessons have taught me the importance of presence and confidence in oneself. When we are at our strongest as humans, we can do just about anything we set our minds to. The trick is finding balance in a life of full self-expression and being responsible for our impact. I continue to work on this daily, striving to live life to the fullest with intention.

∼

My tattoos remain a part of me—they remind me of my strength and power as I navigate life's ups and downs. So I change, add on to, and cover up the ones I feel I need to adapt—making them even more meaningful to me now as I have grown.

I get tattoos because they are a part of my creative expression. They are the insides of me in visual form. They each represent something that will last a lifetime—not something fleeting. I have no regrets about what or where I have my ink—I only have stories to remember and to tell from a well-lived life.

The tattoos I see in my future are few at this point—and I'm sure

they will surprise me with what they end up being. No matter what they end up being, they will represent the things I know in my core through the experiences that I have had or will have (likely a combination of both), the lessons I have learned and continue to learn in this life, and the tools I have in my toolbox.

The ones I'll get if and when the timing feels right:

• Something to represent Russell and me—Ideally with him as a shared experience (and no—not each other's names) as he is my person.

• Something for each of my children—these tattoos are to be determined, and I won't rush them. No matter who my kids become or what they do in their life, they are & will be my greatest adventure yet.

• One that represents our fur babies as they have been family through thick and thin and have taught me many things, including bravery, empathy, and patience.

~

Questions I ask myself as I come up with my tattoos are:

• What part of me am I trying to represent?

• What do I want to think of when I look at or touch my tattoo?

• What are some things that come to mind when I think of symbols for what I'm trying to represent?

• To what degree am I comfortable with strangers' questions or comments on my tattoo (this helps me determine placement)?

• How large does it need to be to be executed precisely with artistic freedom (again, this helps me determine placement)?

• What kind of artist would be best for the tattoo style I envision?

• How will this tattoo age with me?

• When will I access my tattoo as life happens?

• What will I be most proud of if/when people see it?

• What kind of care will this tattoo need over time (based on placement, sun exposure, etc.)?

≈

People get tattoos for many reasons—none of which are wrong or right if they move with intention and purpose. You never know someone's story behind their tattoos, just as you don't know their scars. When you approach a stranger and ask, "What's that tattoo mean to you?" You will likely get a half-assed response as you are a stranger. Keep this in mind before you judge someone on their why. Many of our why's are more complicated than that. In my case, it took me a whole book to express.

≈

Tattoos are considered permanent, and many stigmas are associated with them in society today. Even though I have many tattoos, I don't think they are for everyone. I believe they can be a beautiful, cathartic way to creatively self-express, but I also believe they should come with thoughtfulness and meaning behind them (even if the thought and meaning for you is that it is pretty—it should still be thought through and done intentionally).

ACKNOWLEDGEMENTS

Writing this memoir has been an incredible journey, and I am grateful to have had the support and guidance of so many people along the way. I would like to express my heartfelt appreciation to the following individuals, without whom this book would not have been possible:

Justin: for believing in me and instilling in me the power I have within me to achieve my greatest goals. Thank you for your constant support and for being my biggest cheerleader.

Olivia: for the reminder of how deep love can be.

Moose: for always sitting with me while I write.

Banksy: for reminding me how to be brave and always smiling.

Dad: for pushing me to edit more ... and more.

Ryan: for being my rock and the world's best uncle.

Katie: for loving *him* and pushing boundaries to make dreams come true.

Emma: for showing up and being present even when it's hard.

Pamela: for being my moon sister and for cheering me on and helping me recenter always to just *me*.

Liz: for always bringing the energy that shifts a room to cheery and for the many years of long distance that have never stopped us.

Blair: for doubling down with me in life and in my writing.

Patty & Billy: for the brainstorm that led to the book title and the support to help me get the book out there.

Sandy Huffman: for being the most amazing editor and

coach. The book would not be the same without your countless hours and long conversations.

Miranda Mossburg: for being a fabulous copyeditor.

Michelle Butcher: for the incredible book cover that is the face of my story and for the formatting and creative support through my publishing journey.

Philip Rappaport: for being the first editor who put eyes on my work —making it better than it was before and encouraging me to press on.

Pritesh, Sue, & April: for being curious and asking questions that helped me make my writing stronger.

Finally, I want to acknowledge the countless individuals who have touched my life and inspired me in various ways. From strangers who shared their own stories of resilience and triumph to the communities that welcomed me with open arms, you have all played a significant role in shaping my narrative. Your impact cannot be overstated, and I am forever grateful.

Writing this memoir has been an act of vulnerability and self-discovery. I am profoundly grateful for the support, love, and encouragement I have received from all those mentioned above, and from countless others whose names may not appear on these pages. Your belief in me and in the power of storytelling has fueled my determination to share my truth through the stories of my tattoos.

Thank you.

Sami

ABOUT THE AUTHOR

Sami Moses is passionate about empowering individuals to reach their highest potential and lead healthy, fulfilling lives. She is a Certified Professional Co-Active Coach (CPCC) and a Professional Certified Coach (PCC) who helps her clients understand human nature and achieve success. Sami also holds a BSN in nursing from George Mason University and an MBA from American University. Her background includes working as a Clinical Program Manager across a seven-state integrated health system, nursing, emergency department consulting, and managing health informatics and information systems.

Born and raised in the beautiful landscapes of Utah. Sami's early life instilled in her a profound appreciation for nature. This, along with her love for exploration and adventure, led her to live in various cities throughout the United States and travel abroad frequently. When she's not writing or traveling, Sami enjoys exploring the world of wine, cherishing time with loved ones, and immersing herself in nature. She splits her time between the Pacific Northwest and New York City, where she lives with her husband, daughter, and beloved dog.

9 781088 127797